forgotten

TALES

of

IDAHO

forgotten TALES of IDAHO

Andy Weeks

illustrations by
Cait Brennan

THE
History
PRESS

Published by The History Press
Charleston, SC 29403
www.historypress.net

First published 2015

Manufactured in the United States

ISBN 978.1.62619.708.4

Library of Congress Control Number: 2014958802

In memory of my sister Lois
I miss you!

And thinking of other loved ones, family and friends,
on the other side—
Each a part of my history, always remembered.

Contents

Acknowledgements

I can sit down and write a book—that is, I can conduct interviews and research and put the words together as I've done here. But I could never do all of the other significant things that go into producing a quality book, beginning with the inspiration. I don't usually inspire myself, but those closest to me do. The usual cast of characters—those who give me constant encouragement and inspiration—are gratefully acknowledged: my wife, Heidi, and our son, Brayden. Thank you for believing in me and being my muses. I'm also thankful for the cheers from my mom, Vivian, and my mom-in-law, Linda. I appreciate all you do.

Will McKay, a commissioning editor at The History Press, has been a pleasure to work with on this project. He caught the vision of the book early on and has been excited about its completion. I also appreciate the other remarkable and dedicated members of the press, including Elizabeth Farry,

who helped streamline the production process with her keen eye and expert editing skills, and Cait Brennan for drawing the wonderful illustrations that accompany many of the stories in this book. There's a reason The History Press was named in 2012 by *Publisher's Weekly* as one of the country's fastest growing publishers: its editorial, design and marketing staff are eager, innovative and a pleasure for authors to work with; they know how to produce quality books.

I appreciate Twin Falls resident and personal friend Kelly Klaas, a longtime radio personality in Idaho's Magic Valley, who let me interview him about some of the things he remembered of daredevil Evel Knievel's attempt to jump the Snake River Canyon in 1974, back when Kelly had his whole career ahead of him. Klaas retired from broadcast radio in December 2014 after more than forty years on the air. You know him as *Top Story* host on news radio 1310 KLIX. I appreciate his input on the chapter about Knievel, but most of all I'm thankful for his friendship. He and his co-host, Jill Skeem, have invited me on the air several times to talk about my books, and to both of them I give heartfelt thanks.

Members of the management team at Barnes and Noble in Twin Falls—Michelle Daley, Deby Johnson, Katie Canoy and Alison Bunn—all have become good friends, and I appreciate their help promoting and selling my books and inviting me to book signings. I think I've helped them, too—*wink, wink*—with all of the books I've purchased from them over the years. They keep a nice store, and I

appreciate them letting me browse the shelves even when I don't purchase anything. (Of course, when I'm not buying I'm usually adding to my wish list of future purchases, and so it's a win-win for us all!)

I'm grateful to the many sources—including Harlo Clark, Steve Davis, Gary Guy, Wallace Keck, Gary Stone and Max Yingst, who are mentioned in certain chapters—who entrusted me with their time, conversations and answers to my questions as I reported for the *Times-News*, during which time the foundation for much of this book was laid. That's one of the many things I enjoy as a journalist—I get to meet so many people, hear their stories and experiences and learn new things every day.

Several of the news and feature stories I wrote for the newspaper make up the backdrop of some of the stories contained herein. A couple of stories—comprising Chapters 7 and 16—are published in their entirety, and I appreciate *Times-News* publisher Travis Quast for giving me permission to use them. Likewise, I appreciate editor Greg Lalire and others at *Wild West*, a classy and informative national magazine about the Old West, for letting me write an article for them—and allowing me to reuse it here—about the death of a black Mormon sheepherder named Gobo Fango in late 1800s Idaho. The article was published in the December 2011 issue of the magazine and is included herein as Chapter 2.

Lastly, and as always, I appreciate the authors and journalists whose articles, books and websites helped me in

the research and writing of this book. As a fellow journalist, I know how thankless that work can be at times. Thank you for your contributions.

A Tale Is Lost Only until It Is Retold

During a reporting venture that put me on the phone with several museums in Idaho's Magic Valley, certain stories told to me by the curators left me thinking of a future book project: a compilation of the strange and forgotten tales in Gem State history. Luckily, I didn't have far to look before finding a publisher. The History Press, publisher of my *Ghosts of Idaho's Magic Valley*, already had a series called Forgotten Tales. But it wasn't until about two years after I thought of the forgotten tales book that I actually contacted the publisher. The editorial board liked the idea, and the result of our combined effort is the volume you now hold in your hands.

I hope you like it. A writer doesn't produce work in a vacuum; the printed word is supposed to be shared, distributed and enjoyed by others. I hope you enjoy this one.

I remember the first book I read. It was a small paperback about dinosaurs. Like most young boys, I was interested in

the large reptilian creatures, my imagination going wild about such giants walking the earth. I wasn't a reader at the time, but I remember enjoying the book and learning about brontosaurus, stegosaurus, triceratops and, my favorite, tyrannosaurus rex, a ferocious meat-eater with a small brain, little hands and a big appetite. I was captivated by the illustrations of a triceratops battling Mr. T Rex, hearing the roaring, gnashing sounds in my mind. What would it be like to live in the age of dinosaurs? I wondered. What if dinosaurs were real today?

That is how the first book I read affected me. It wasn't always so.

My mother encouraged me to read other books, such as the collection of Hardy Boys mysteries that my older brother, Craig, had enjoyed reading as a young man. I picked up one book, whose cover enticed me with its atmospheric artwork, and I plopped down on the bed one afternoon to take a gander. I didn't get very far into the yarn, but looking back now I wonder why. Books have become an integral part of my life, both as a writer and reader, and today I appreciate even those short mysteries aimed at a young audience. If all books at the time, however, had been like that ol' dinosaur book I read, maybe I would have enjoyed reading other books in my youth.

This book is not about dinosaurs (though there is one story about ancient fossils), but I hope you find at least some of these tales as interesting as I found that first book I read years ago. I hope this is a book you'll keep in your library,

someplace handy so you can share the stories with others. Stories from our past, like dinosaurs, have to be uncovered and shared so they can live on in the museums of the mind. I've tried to put muscle to the bone, but these story fossils cannot be fully covered in flesh because, frankly, history doesn't allow it. There are always missing pieces to the historical puzzle, which necessitates further research and evaluation and writing. Nonetheless, for the purposes of this book, which is about stories nearly lost, I believe it's a decent contribution. Could it be better? Sure it could—but the deadline looms!

As for Idaho, it became the forty-third state of the union on July 3, 1890, but people have lived here much longer. In 1959, excavations were conducted in the Snake River Canyon and at a place called Wilson Butte Cave, where it was determined human activity existed here nearly fifteen thousand years ago. Several ancient bands of Indians, including the Nez Perce, Shoshone and Bannack tribes, dominated the territory that is today Idaho.

Later, the area was explored by the white man, including members of the Lewis and Clark Corps of Discovery Expedition, commissioned by President Thomas Jefferson, that aimed to "put a face" on America's backcountry. The party entered the area on August 12, 1805, at Lemhi Pass on the continental divide near the Idaho-Montana border.

A few years later, in 1811, the Wilson Price Hunt party tried traveling from St. Louis, Missouri, to Astoria, Oregon, strictly by water. They had much success, but not fully; the party ran into trouble while trying to navigate the swift but narrow waterfall named Cauldron Linn near present-day Murtaugh in southern Idaho. So dangerous was that venture that it prompted the party to ground their canoes and make the rest of their journey on dry land. Andrew Henry of the Missouri Fur Company, who built the first American fur post west of the Rocky Mountains in 1810 at Henry's Fork; the Hudson's Bay Company with its British roots; and members of the Pacific Fur Company all found value in exploring, trapping and trading in the place now called Idaho.

By the 1840s, emigrants traveling from the Midwest to the Pacific Northwest wound their way through Idaho along the Oregon Trail, as did pioneers and stagecoaches from Salt Lake City to Boise, using such trails as the Kelton Freight Road as their main thoroughfare.

No matter how they came or where they came from, with its beautiful scenery, plentiful wildlife, precious ores and thriving rivers, they considered the place a gem among the West.

There are many reasons Idaho is considered the Gem State, a nickname given because of the many varieties of gemstone found here. As a newspaperman, however, I've met many people who consider the state a gem because of

the plethora of recreational activities that abound within its borders. Its rugged wildernesses, virulent rivers and streams, scenic trails and active lakes and reservoirs are just some of the things that provide hunting, fishing, hiking, mountain biking, off-road riding and boating opportunities and more. Some, of a different bent, call Idaho a gem because of its small agricultural communities and rural landscapes or because it is less populated than other states and is a place where fresh air really is fresh.

There's yet another reason for which we could apply the nickname but that I did not fully consider until I started researching topics for this book. Idaho history is filled with forgotten tales, stories that might have been well known when they were first told but became lesser known through the din of years. A few examples, which you'll be able to read further about later in the book, include:

- Many people know the controversy between whites and blacks in U.S. history, but how many know that deadly feuds existed between sheepmen and cattlemen in the early days of the American West? I didn't know this until I came across the name of Gobo Fango while investigating another topic for a newspaper article I was writing for the *Times-News*. Fango, I had learned, was a black Mormon sheepherder who in the late 1800s was shot and killed by a white cattleman. There was more to his story, of course, and so I researched it and wrote an

article about it for a national magazine. Read it in Chapter 2.

- In the mid-1900s, Twin Falls residents were abuzz with news that an alien spacecraft had landed in a quiet neighborhood one summer morning. The news spread like wildfire, hitting national headlines, and drew the attention of government officials and FBI agents. Was the episode a hoax or the real-life visit from an out-of-this-world being? Find out in Chapter 17.

- If you've ever visited Lake Coeur d'Alene in scenic northern Idaho, you'd never guess that beneath the cold water lie several old-model automobiles. How'd they get there? You can probably figure it out, but if not, you'll want to read Chapter 29.

- There's even one story here about Evel Knievel in Chapter 19. His daring attempt to jump the Snake River Canyon is well known across the country, so why is it included in a book of forgotten tales? Because there are parts of the story that are not generally known among the population, such as the reason the jump failed. Was it human error, mechanical failure or Mother Nature?

The Gem State is indeed remarkable in many ways, including its interesting and colorful past. Read on, as there are many more lesser-known tales that help make up Idaho history. I hope you enjoy the stories and share them with others.

PART I

MADNESS AND MAYHEM

RIDING WITH JOHN WILKES BOOTH

It was supposed to be an unassuming evening for the bearded president of the United States, but April 14, 1865, turned into one that America would not forget. Abraham Lincoln, the country's sixteenth president, sat with his wife in Ford's Theater in the nation's capital city watching the farcical three-act play *Our American Cousin*, when, unbeknownst to Lincoln and the crowd about him, actor and Confederate sympathizer-turned-assassin John Wilkes Booth raised a revolver and pointed it at the head of the sitting president.

Bang! Lincoln didn't know what hit him. His brain terribly traumatized by the slug and on the verge of death, the president collapsed, causing his wife, Mary Todd Lincoln, to scream, and the country began its mourning.

Originally, Booth had conspired with other devious minds to kidnap the president and take him south, where he'd be held until, the kidnappers hoped, an exchange

could be wrought for Confederate war prisoners. The first attempt to kidnap the president was to take place on March 17, 1864, while Lincoln was on his way to attend a viewing of the play *Still Waters Run Deep* at the Campbell Hospital. The president changed his mind, however, and instead spoke to the 140th Indiana Regiment, where he presented to the soldiers a captured flag. Booth later reformulated his plan, intending to kidnap Lincoln at Ford's Theater, but his comrades saw the act as unfeasible.

Then history intervened. Once Richmond was defeated, Booth changed his plan of kidnapping to one of murder. A frequent performer at Ford Theater, it wasn't a great feat for the soon-to-be assassin to gain entry to the president's box, this at a time when security for presidents was less than stellar. That, however, would change after this fateful night. Booth entered the president's box. Lincoln, who sat between his wife and Major Henry Reed Rathbone, was leaning slightly forward to better see one of the orchestra members when, from a distance of about four feet behind, Booth lifted his revolver to the president's head and pulled the trigger. After the evil act, Booth shouted either "Freedom," according to one witness, or "Revenge for the South," according to another. Rathbone tried to stop the fleeing assassin, but Booth wrested away and fell from the balcony, injuring his leg and landing on the stage. Picking himself up, he again shouted, this time, "*Sic simper tyrannus!*" and then he fled out the back of the theater, escaping on a horse that was held for him by accomplice Joseph "Peanuts" Burroughs.

The tragedy at the now historic Ford's Theater struck at a most inopportune time. When Booth aimed his revolver at the unsuspecting president, it was just five days after General Robert E. Lee, commander of the Confederate Army of Northern Virginia, surrendered to General Ulysses S. Grant and the Union Army of the Potomac. After four years of civil war, peace was finally on the horizon. And then, five days after the official end of war, *Bang!* Lincoln's head jerked forward, unconscious, blood spatter on his chair.

The president was taken to a house across the street from the theater, one owned by a Mr. Peterson, and into the room of a War Department clerk, where his unconscious mind slowly sank into oblivion, his breathing growing fainter, his body giving up the ghost on the morning of April 15. The attending physicians retreated from the room, approached Mrs. Lincoln and solemnly declared, "It is all over! The president is no more!"

The assassination took the fledgling country by storm and thereafter upped the ante on security for a sitting president. As the country mourned, Lincoln's body was placed on a train in Washington, D.C., and transported to his hometown of Springfield, Illinois, where it was laid to rest at Oak Ridge Cemetery, his memory thereafter flying on the wings of history.

Lincoln is today regarded as one of the country's most revered presidents, mainly for his efforts in freeing black slaves. Even today, however, not everyone shines a light on Lincoln's actions. Some contend he should be known best

for the millions who died in the Civil War, still the country's bloodiest conflict. As with any president who sends his country to war, the decision did not come easy—but it was one that Lincoln firmly believed in, a cause that, if successful for the federal government, would be greater than the misery of war.

During his second inaugural speech in 1865, Lincoln closed, entreating the nation, saying:

> *With malice toward none; with charity for all; with firmness in the right, as God gives us to see the right, let us strive on to finish the work we are in; to bind up the nation's wounds; to care for him who shall have borne the battle, and for his widow, and his orphan—to do all which may achieve and cherish a just and lasting peace, among ourselves, and with all nations.*

His most notable work was issuing the Emancipation Proclamation, which freed the slaves and irritated southerners and their sympathizers.

And what became of the assassin?

Several stories exist about what happened to Booth after the assassination, including one that says Booth was shot in a barn by his pursuers. Another story says it was not Booth but another man who was killed. Instead, the assassin escaped, only some forty years later to die by his own hand in Enid, Oklahoma. For our intents and purposes, this is where the tale becomes interesting.

The Traveling Mummy

After a man claiming to be John Wilkes Booth shot himself in Oklahoma, the body became mummified and, much to the chagrin of the country, wound up on tour. At the time, people truly believed it was the body of Lincoln's assassin, but with the hindsight of historical fact behind us, we now know differently. The man claiming to be Booth was a man named David E. George, who, according to an October 11, 2012 *Times-News* article by Mychel Matthews, as part of a series that looks at various scenes in local Idaho history,

> *bore a striking resemblance to Booth, and could spout Shakespeare at the drop of a hat. Some folks in Enid took George's confession seriously. An undertaker embalmed the body, fully expecting that someone from the government or Booth's family would claim it. But the body—which eventually became mummified—remained unclaimed until an old friend (Finis L. Bates) came for it…After hearing of George's suicide and mummification, Bates asked a judge in Oklahoma for the body. The judge agreed, thinking that Bates would give his friend a decent burial. Instead, Bates wrote a book called* The Escape and Suicide of John Wilkes Booth—Written for the Correction of History *and put the mummy on tour. They say that the mummy made more money on tour than John Wilkes Booth ever did as an actor.*

The mummy John-not-Wilkes-Booth was leased to William Evans, a carnival master who paid a $40,000 bond, "plus a fee of more than $2,000 a year," according to Matthews, a talented history buff and storyteller, to display the mummy in his traveling freak show. Bad luck or fate, whatever you want to call it, eventually intervened when "a train wreck destroyed [Evans's] carnival business."

His own entrepreneurial spirit wouldn't let the mummy rest, however, and John, as he lay in a coffin, toured "from town to town in a luxury Pullman rail car." People felt as if they had, in some way, been a part of history. They had actually seen the body—or so they thought—of Lincoln's assassin. Viewers looked upon the mummified remains with disgust and morbid curiosity. The tours didn't last, however, and eventually Evans split town with the mummy. As for the Pullman car, he left it at a farm in Declo, and because it is part of local and Idaho history, it wound up in the Cassia County Historical Museum and is on display to this day. It's an unassuming-looking rail car, but one with a history that other such cars quite likely cannot compare to, either back then or now.

Chapter 2

THE DEATH OF GOBO FANGO

One day in early February 1886, Frank Carl Bedke, a forty-one-year-old Prussian-born cattleman, mortally wounded thirty-year-old black Mormon sheepherder Gobo Fango while the latter was tending his woollies in southern Idaho Territory.

At least two accounts of the shooting exist, but unanswered questions remain 125 years later. One account comes from Oakley justice of the peace Claus Herman Karlson, who transcribed Fango's version of the story from the victim's deathbed.

Herman E. Bedke, a grandson of the shooter, provided the second account in the 1970s. With Fango's narrative we are left to wonder if penman Karlson exaggerated any details. The Bedke account, based on family tradition and hearsay, has definite problems.

Although Frank Bedke was twice tried for the killing, records of the court proceedings have gone missing for

more than a decade. What remains of the historical record, filed in the Cassia County Courthouse in Burley, Idaho, are "court notes," which describe very little. No one disputes that Bedke shot Fango. But was it because Fango was black, because he was a Mormon or because he was a sheepherder? Perhaps Fango had become Bedke's sworn enemy for all three reasons. On the other hand, Fango could have done something to antagonize Bedke. Could the cattleman have acted in self-defense? After all, juries in two court hearings declined to convict the shooter.

Certainly "Gobo Fango" is an interesting name, as is the story of his life and death in the desert Northwest. Disputes between cattlemen and sheepherders were common in the Old West. They were not always declared and not always violent, but sometimes they escalated into range wars.

By the 1870s, southwestern Idaho was a drought-stricken, overgrazed land, with cattlemen and sheepherders in dispute over grazing rights. In an effort to avert violence between the factions, the Idaho Territorial Legislature in 1875 passed the Two-Mile Limit Law. The statute, at first applicable to only three counties, was extended in 1879 and 1883 and by 1887 was made general law.

The law read, "It is not lawful for any person owning or having charge of sheep to herd the same, or permit them to be herded, on the land or possessory claims of other persons, or to herd the same or permit them to graze within two miles of the dwelling house of the owner or owners of such possessory claim." The law did little to erase conflict

on the range, however, and cattlemen eventually set up their own "deadlines"—boundaries the sheepherders were not to cross. In early February 1886, Fango was herding his sheep in Idaho Territory's Goose Creek Valley beyond the area cattlemen's deadline. Apparently, the sheepherder also was close to the two-mile limit of property claimed by cattleman Bedke.

Frank Bedke, born on November 22, 1844, in Rieth, Prussia (present-day Germany), traveled at age sixteen to New York and never returned home. Toward the end of the Civil War, he sailed from Boston around Cape Horn to San Francisco. In 1868, he ventured out for the next nine years to prospect and mine in Montana, Nevada and Utah Territories.

At some point his interest turned to ranching. In 1878, cattlemen hired Bedke to herd ninety-seven head from Utah Territory north to the Goose Creek Valley. Settling in an area later known as Bedke Spring, he rode for other cattle operations while establishing his own herd. He married Polly Ann McIntosh in 1882.

Born around 1855 in South Africa's Cape of Good Hope, Gobo Fango arrived in Boston in 1861, the opening year of the Civil War. The Henry Talbot family, white Mormon immigrants, had taken young Gobo under their wings and now headed to Utah Territory to join other Latter-day Saints. The young man grew up as the Talbots' indentured servant in Kaysville, north of Salt Lake City. He later entered the service of Bishop Edward Hunter in Grantsville.

Fango became a sheepherder and moved to Oakley, Idaho Territory, to work for Hunter's sons, early settlers of the Goose Creek Valley. The Prussian and the South African thus found themselves living near each other at a tense time in the history of Idaho's rangeland.

On February 7, 1886, Frank Bedke was on his way to a family gathering when he noticed sheep grazing on the grass near his property. He and his friend investigated and soon came across the unwanted neighbor Gobo Fango. Little did Fango know this would be his last day on the range. According to a journal entry by Karlson, dated February 1886, Fango dictated to him the following version of the shooting (original grammar and spelling left intact):

> *I was hearding sheep about 3 or 4 miles from Bedkie's Ranch in little Basin about 9: o'clock this morning (Feb 7th). Bedkie and another man came up on horses and Bedkie ordered me to move off that part of the range. I refused to go unless he could show me a pattent for the land, he said I Will show you the pattent, I said I would like to see it, he got off of his horse his partner holding him, he came up to me knocked the gun out of my hands pulled out a deringer and shot me over the left eye. I fell and as I tried to get up he knocked me down with the deringer, I then said I will get even with you Mr. Bedkie, he then said you Black Son of a b— I will kill you then fired another shot into me his partner then said let him alone and Bedkie said no by*

g-d I Will kill him right here. He then shot me again and I knew no more. When I came to I herd Bedkie Say he Won't go far he Will die right there, then got up after they Was out of sight and Walked a distance of 4 miles to Walter Matthews house.

Herman Bedke, a former magistrate judge, described the incident a bit differently in a paper from a family volume titled "They Called Me Bedke." He claimed to have obtained the information from court records, at the same time confessing that much of what he relates "has been handed down through the family for years." According to the paper, Frank Bedke was en route to a family gathering that cold day in 1886 when he felt "prompted…to investigate northwest of his holdings." Frank sent his wife ahead, telling her he would catch up later, while he and a friend went to check things out. Herman added:

As he rode down through the grass and brush he observed sheep grazing in the very close proximity of his holdings, well within the two-mile limit. He spotted the sheep camp and while it was still early afternoon he rode with his companion Cawfield toward the sheep camp. As he approached the area of the camp, the Negro sheepherder armed with a rifle jumped out of the brush or grass in front of his horse and said, "Are you Bedke?"—to which Frank replied, "Yes." Frank was then ordered by the sheepherder to retreat and move back

> *and get out of the area. At this direction, Frank spurred*
> *his horse and the horse jumped toward the Negro either*
> *knocking the Negro down or making him move so fast*
> *that he fell. Frank jumped off his horse and attempted*
> *to disarm the Negro.*

In the scuffle the gun went off, and the black man—later determined to be Gobo Fango—was struck in the neck by the bullet from his own gun.

The only eyewitness to the incident was Frank Bedke's companion, identified by Herman Bedke as J. Cawfield. Frank instructed Cawfield to go tell his wife what had happened while Frank rode to Albion, the county seat at the time, to report the "accidental shooting" to the sheriff. Frank Bedke was tried twice for the shooting of Gobo Fango, but without any extant court records, it's impossible to say what testimony was given or why Bedke escaped any punishment.

"We don't really know what happened to them—they're just gone," Cassia deputy recorder Viki Osterhout said of the court documents.

According to the court notes, however, on April 15, 1886, the first day of the first trial, district attorney H.S. Hampton moved that the court conduct a postmortem examination of Fango's body. Bedke was arraigned the next day, and he furnished the $3,000 required for his bond. On April 17, he pleaded not guilty.

The hearing lasted nine days (April 15–24) and ended in a hung jury. "Now come the Jury in this cause into court

and report that they are unable to agree upon a verdict, and they are thereupon discharged from further consideration of this case, and this cause is hereby continued until next term," the court notes conclude for April 24. The notes do not give dialogue, background or further explanation. For example, a note on April 22 indicates what was taken into evidence but little more than that: "Thereupon the plaintiff...introduced in evidence the clothing of Gobo Fango, the deceased, worn at the time of the shooting and also the bullet extracted from the neck of said deceased, and here the testimony for the prosecution closes." A second

trial began on March 21, 1887, and lasted little more than a week. On March 29, the jury found Bedke not guilty.

Case closed, but not the mystery or controversy.

While it is uncertain who first pulled a gun, it most likely was Fango. We know Fango had a pistol, which, according to Karlson's journal, he pulled while requesting to see Frank Bedke's license for the land. Did Bedke feel threatened by Fango's weapon? If Karlson's account is accurate, Bedke went further than trying to simply defend himself. Only after knocking the pistol from the sheepherder's hands did Bedke fire his first shot.

Fango, according to Karlson's account, was shot three times—twice in the head ("one over the left eye and one in the back of his head") and once in the abdomen. His head also "was fearfully beaten up with Bedkies [*sic*] pistol." It is not known whether the physical evidence and/or testimony of Bedke's companion, Cawfield, supported those statements. Even the date the shooting took place is not absolutely certain.

Fango's supposed deathbed story lists the date as February 7. However, an undated article by the Cassia County Historical Society titled "Negro Sheepman Lost Life in Idaho Range War" says the shooting took place during the night or early morning hours of February 10 and that Fango died "a few hours" after reaching Walter Mathew's house.

According to some modern writings on the incident, Bedke was an influential member of the community and was not fond of Mormons. Considering the biases of the

time, the fact that Fango was a black Mormon made him doubly objectionable.

It's possible Bedke would have treated any sheepherder, even a white gentile, the same way. As for the missing records, Herman Bedke explained at the end of his account:

> *About 20 years ago when I first started practicing law, someone was examining the file of this case in the courthouse, and I remember distinctly examining the file folder. During the preparation of this story I attempted, with the courthouse people, to find that file, but it has been lost or misplaced, and the file is not available at this time.*

Fango left a will, transcribed by Karlson on February 9, a copy of which is preserved in the Cassia County Courthouse. The sheepherder dictated to Karlson that "my boddy [*sic*] be decently buried, with proper regard to my station and condition in life and the circumstances of my estate." He directed that money go toward funeral expenses and friends, including "the needy por [*sic*] people in Grantsville," and the remainder, about $400, to the Church of Jesus Christ of Latter-day Saints for the building of the Mormon temple in Salt Lake City. He appointed Edward Hunter of Grantsville and Rosel Hunter and William Hunter of Oakley to be "the executors of this, my last will and testament."

Over the years, Fango has become something of a hero in Mormon history. In the March 2003 issue of the *Friend*,

a church magazine geared toward young readers, Fango's story was dramatized in an article that described him as "a valiant saint," "a courageous child" and "one of the first African pioneers to join the early Saints in the West."

Perhaps it's fitting that Gobo Fango be remembered that way. He didn't live an easy life, and his death was just as hard. He was laid to rest in the Oakley Cemetery. The headstone, bleached white by more than a century of sun and storm, simply reads:

> GOBO FANGO
> DIED FEB. 10, 1886
> AGED 30 YEARS.*

*. This story by the author originally appeared in the December 2011 issue of *Wild West* magazine, titled "The Death of Gobo Fango: Although Accounts Differ on His Shooting by a Prussian Cattleman, This Black Mormon Sheepherder from South Africa Has Become a Latter-day Hero." Used by permission.

Chapter 3

The Infamous Lady Bluebeard

The young bride, though forbidden from entering one of the rooms in her wealthy husband's home, turned the lock just the same, opened the door and… was struck with horror at the grisly sight: female bodies hanging from hooks on the walls, the floor awash with blood. She dropped the key, staining it scarlet, and fled from the nightmare.

Bluebeard, as the French folktale goes, was a not-so-noble nobleman who killed his several wives and hung them on meat hooks in the forbidden room. His last wife survived by sheer curiosity at trespassing where she was told not to go. It's not a lovely story at all, and neither is the true account of Lyda Trueblood, Idaho's most surprising serial killer, whom history has dubbed "Lady Bluebeard."

Lyda Anna Mae Trueblood was born on October 16, 1892, in Keytesville, Missouri, and started life as other children: innocent, with the whole world at her feet. It's the steps we take in life that lead us to our future, good or bad. Lyda chose to walk a dark path, arriving at the darkest spot a person can enter.

It began on March 17, 1912, when she married her first husband, Robert Dooley, just six years after moving to Twin Falls with her family in 1906. The couple, struggling to make ends meet, moved in with Robert's brother, Edward Dooley, on his ranch. It was there that she conceived their first and only child, Lorraine, who was born in 1914. The next year, things started to happen.

Who knows what evil thoughts lurked in Lyda's mind as she came of age. Maybe she never had them until later, after she was married. We only know that they eventually were there, somewhere, until she chose to act upon them. She took aim at her brother-in-law, Ed, who in August 1915 became severely ill and died of ptomaine poisoning. Two months later, her husband, Robert, fell ill and died of what was first termed typhoid fever.

Funerals were held, burials took place and life moved on—for Lyda and her young child, anyway. At the time, what was a young single mother supposed to do but to marry again? This she did to a man named William G. McHaffle in June 1917. The couple started out happy, it seemed, until death struck and took young Lorraine, just three years old. In hindsight, it is believed that death didn't come naturally

but was invited by the mother. Grieving for the loss, whether pretend or truly feeling the pull of the episode, Lyda moved with her husband to Montana, which was to be William's place of death. According to the death certificate, he died on October 1, 1918, of influenza and diphtheria.

Lyda didn't waste any time marrying her next husband, Harlen C. Lewis, the following March. By that July he, too, was dead. Lyda married a fourth man, this time Pocatello resident Edward F. Meyer. While Lyda had been married several times before and didn't seem to like it, Edward was happy with his new bride. His happiness turned sour when, on September 7, 1920, not even a month after they tied the knot, he fell ill and died of typhoid fever. Or so the death certificate read.

While each of the deaths seemed natural enough, the numbers started adding up—and so did the suspicions. If the deaths really were natural—her four husbands were supposedly infected with disease, as was her daughter—why did Lyda herself not become ill?

One suspicious mind was Earl Dooley, a chemist and relative of Lyda's first husband, Robert Dooley. After he took his suspicions to the authorities, Twin Falls county prosecutor Frank Stephens ordered the exhumation of the five bodies, which had not decayed as much as they normally should have once interred. This alone further

raised suspicions, and when testing was done, traces of arsenic were found in the bodies.

Lyda, it appeared, had killed her daughter and each of her known four husbands. (It is rumored that she may have married three other men, but lucky for them, she divorced them instead of sending them to their graves.)

As is always the case with such crimes, questions are asked; some of them are left unanswered, such as "Why did Lyda murder her own daughter?" There is never an acceptable reason for coldblooded murder, but knowing a

little about her husbands' finances might shed some light on what may have caused her mind to teeter. That old crime favorite, greed, seems to be the answer.

According to an Idaho State Life Insurance Company in Boise, all four of Lyda's known husbands had held life insurance policies that listed her as the beneficiary. It's estimated that she collected more than $7,000 at the passing of her first three husbands, a substantial sum by that day's standards.

Facing criminal charges did not deter Lyda from marrying once more, this time to naval petty officer Paul Southard in Hawaii, where the murderess sought distance from Idaho law. Perhaps she married Southard—with intent to keep her fifth husband—in an effort to "prove" to authorities that she was not the culprit in the previous deaths. Or maybe she had every intention of becoming a black widow once more. Whatever her intention, it wasn't realized, because the long arm of the law reached across the ocean to the big island and extradited Lyda, now Mrs. Southard, back to Idaho. She was arraigned on June 11, 1921. Her trial made national headlines.

"Mrs. Lyda Southard pleaded not guilty today when arraigned before Probate [Judge] Duvall on the charge of murdering Edward F. Meyer, her fourth husband," read a *New York Times* article for that day.

Mrs. Southard, who was returned here from Honolulu, where she was arrested, was accompanied by her father, W.J. Trueblood, and her counsel. She was permitted to leave without guard to consult with her attorneys in their offices. "Don't let them question me," said Mrs. Southard before she was taken to a cell. "I am not well enough to see anyone." The last 120 miles of the journey from Honolulu was made overland by automobile from Wells, Nev., to avoid crowds. Mrs. Southard is suffering from nervous headaches, with indications of a nervous breakdown, officials say.

Poor Lyda.

Not!

She wasn't convicted for several weeks. "Mrs. Lyda Meyer Southard, convicted here last week of the murder of Edward F. Meyer, her fourth husband, was sentenced today in District Court to from ten years to life imprisonment," read a *New York Times* article for November 7, 1921. "The defendant stood up, fixed her eyes on the bench, and received the sentence without a tremor. Notice of appeal was filed by her attorneys, but a stay of execution sentence was not asked."

It wasn't enough that she was a demented psycho, but she also was impatient. Just months before her parole, Lyda escaped the Old Pen on May 4, 1931, fleeing to Colorado, where she took up residence as housekeeper for Denver resident Harry Whitlock, whom—hit me with a broom—

she married in March the following year. Whitlock had some wit about him, however, and was instrumental in his new bride's recapture. Lyda was arrested again on July 31, 1932, and returned to her empty cell in Boise that August. Almost another decade later, in October 1941, Lyda was paroled. She received a final pardon in 1942, legally anyway—but not socially. To avoid ridicule and mistreatment, Lyda eventually changed her name to Anna Shaw but today is better known as Lady Bluebeard.

Though she did not hang her husbands' bodies by meat hooks in a blood-soaked room, she was, according to historical hindsight, the cause of their deaths. What's more, she allegedly murdered her own child. If all that is true, the name Bluebeard aptly applies to Lyda Trueblood Dooley McHaffie Lewis Meyer Southard. Heck, it's even shorter and easier to pronounce!

Lady Bluebeard died at age sixty-five on February 5, 1958, and was buried in the Twin Falls Cemetery, where it is said her spirit does not rest because of the ghastly deeds she committed in the flesh. Serves her right!

Chapter 4

THE ASSASSINATION OF IDAHO'S FOURTH GOVERNOR

In U.S. history, there have been four presidents who died at the hand of assassins: Abraham Lincoln (sixteenth president), James Garfield (twentieth president), William McKinley (twenty-fifth president) and John F. Kennedy (thirty-fifth president). In Idaho, one governor met the same fate. His name was Frank Steunenberg, governor number four, and before he entered politics, he was a newspaperman. While he had plenty of opportunity to offend people in both his careers, it was during a political battle between labor and management that he irritated his opponents and they eventually took aim—but not until he was out of office. Steunenberg's death came in 1905.

Instead of bullets striking him down as they did our four assassinated presidents, what killed Steunenberg was a bomb, carefully placed at a gate at his Caldwell home on December 30, 1905. It was not a way to celebrate the close

of an otherwise successful year. For those who had it in for the former governor, it was a year of debacle and debate, of heated contests and threats.

Steunenberg, who hailed from the Midwest, came to Idaho in 1886 and soon after arriving became involved with the local political climate. By 1890, when Idaho gained statehood, he had been elected to the state legislature, and in 1896, he was elected governor. It was a heated time in many ways, especially for the mining industry in northern Idaho. Steunenberg, having been nominated to the seat as both a Democrat and Populist, was the state's first non-Republican governor, and his election caused ire among members of the corporate mining industry. They feared the new governor would not support them if there was a strike, which there eventually was, and so they increased their wages for workers. Most companies, that is, except for the Bunker Hill Mining Company.

"Miners in the rich silver districts near Coeur d'Alene, Idaho, had been struggling to unionize and gain better pay and working conditions since 1892," according to an entry on History.com.

> *Radicalized by their initial defeats, an increasing number of miners began supporting the violence-prone Western Federation of Miners (WFM), which advocated*

47

*aggressive tactics and worker control of industry. Alarmed
by the growing influence of the WFM, Coeur d'Alene
mine owners attempted to bust the union in 1899, and the
WFM responded by blowing up one mining company's
huge and costly concentrators with dynamite.*

That was enough for Steunenberg to request troops from
the federal government to help quell the rebellion. "The
soldiers placed the region under martial law and herded
hundreds of miners into makeshift prisons, ignoring their
constitutional rights to know the charges and evidence
against them. Steunenberg's actions restored order in the
Idaho silver mines, but also earned him the lasting enmity
of many radical WFM members."

Many union supporters viewed the actions of the
governor as betrayal, but that did not stem martial law.
It remained in place through the end of his term, and
Steunenberg did not seek reelection in 1900.

It was rumored at the time, however, that Steunenberg
had left office with a large sum of money under his belt,
given to him by mine owners. The ire that sparked with
his enemies raged until distraught individuals took decisive
and evil action.

Enter Albert Edward Horsley, better known as Harry
Orchard. Actually, there were three men who allegedly

conspired to commit murder, each a member of the radical Western Federation of Miners, but it was Harry Orchard who was charged for the political assassination of Steunenberg.

Though the crime became a sensational headline topic at the time, with the news reaching across the country, it is not commonly known by modern Idahoans. The bomb that went off on that cold December day in 1905 didn't kill the former governor immediately, but it wounded him enough that it wasn't long that day before he died while laying upon his own bed.

As for Orchard, he at first denied having anything to do the bombing but later confessed to the killing, but he implicated others in the crime. He said the WFM had hired him to kill Steunenberg and, over the years, seventeen other men who posed a threat to the organization. Charles Moyer, president of the WFM; "Big Bill" Haywood, general secretary; and labor activist George Pettibone were all arrested in 1906 for the crime, but it was Orchard who would pay the price for killing Steunenberg; each of the other men eventually was acquitted. Orchard spent the remainder of his life at the now historic penitentiary in Boise.

Remembering the tragic yet historical episode, the Associated Press published an anniversary article by Anne Wallace Allen on December 30, 2005:

A century after a bomb killed former Gov. Frank Steunenberg, Idaho residents are remembering his assassination and the events surrounding it with new exhibits, lectures, a play devoted to the trial and a textbook for schoolchildren.

The killing of Steunenberg, 100 years ago Friday, brought national attention to the deep antagonism between the Western Federation of Miners and the owners of Idaho's silver mines as workers worldwide demanded better conditions.

It led to what was then called "the trial of the century." Defendants included labor boss William "Big Bill" Haywood, who was accused of hiring the assassin.

"So much of the time in Idaho we think we're so disconnected from what's going on in the world," said Amber Beierle, a Boise State University graduate student who created a Steunenberg exhibit, currently on display at the Ada County Courthouse. "Really, all eyes were on Boise during this period."

Chapter 5

Execution at the Old Pen

The old cliché that fact can be stranger than fiction holds true when it comes to one story about the Old State Penitentiary in Boise. The facility, built in 1870 and functional as a prison from 1872 to 1973, is rumored in paranormal circles to be one of Idaho's most haunted places. Phantom sounds, shadow figures and oppressive spirits are thought to hang out in many parts of the building but are perhaps most recognized in the maximum-security cells, where the hardest of the facility's criminals were confined. There also are rumors that its gallows are haunted.

One young man with whom I spoke for a previous book shared a story of his first visit to the Old Pen as part of a tour group he was with. While walking its grounds on the afternoon tour, he looked into one of the rooms and, to his astonishing fear, saw a man hanging by a noose. The young man turned to catch the attention of his adult leaders, but when he again turned to the room, it was empty.

Was this a hallucination or a tall tale, or did the young man catch a vision—a residual imprint of a past episode—of something frightening that occurred here long ago? According to research I conducted on the Old Pen, it seems the latter scenario could very well be the case.

During the prison's 101 years in operation (it went from jail to prison to penitentiary) and even though it has a built-in gallows, it is believed that only one execution by hanging ever took place here—and one that is surely memorable for the sheer terror of its conclusion.

Evil people do evil things. Raymond Snowden, possessing a demented mind, succumbed to gross evil when, on September 23, 1956, in Garden City, he lashed out at a woman named Cora Dean, killing her with a slash to the throat, severing her spinal cord and stabbing her thirty times. So brutal was his attack that he was dubbed "Idaho's Jack the Ripper."

Police arrested Snowden after finding the bloody weapon, left for some unknown reason in the gutter near a Boise cigar store. Once in custody, the criminal mind boasted about killing two other women, though he was convicted only of Cora Dean's murder. It was enough, and Snowden's punishment fit the crime: death.

His execution was to take place on October 18, 1957—but it would not go as planned. A crowd gathered to watch the hanging through a glass window. As the spectators settled into their seats, the mood was both somber and anticipatory. Visitor feelings were mixed: they wanted justice for what had been done to Cora Dean, and they wanted revenge. But still, watching another person die, no matter how much he may have deserved it, was nonetheless an unpleasant experience.

Things were about to get even more unpleasant. But before the execution, Snowden took time to pray.

"Eyeing the huge hook hanging from the ceiling, the dangling rope, noose and trap door at the gallows in the Old Idaho penitentiary, former warden Orvil E. Stiles recalls the state's last execution," read a January 9, 1987 *Los Angeles Times* article by Charles Hillinger. "I was here with Raymond Snowden 30 years ago on the last day of his life. Snowden murdered a woman in a Garden City bar. He prayed alone with me. Then he was led into this room. He was the calmest man in the execution chamber, far calmer than I was."

Shortly after midnight, Snowden was brought to the gallows, where his head was quickly covered by a cloth bag and a noose strung around his neck. He was asked if he had any last words, to which he responded, "Yes, I do but I don't know how to say it." Shortly thereafter, the trapdoor was pulled open, and the murderer fell.

Death by hanging, if done properly, is supposed to break the neck, making death come more easily. Fate intervened,

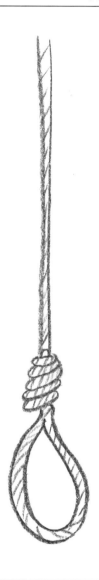

however—or, depending on your moral or political stance, perhaps a little more justice—and the fall failed to break Snowden's neck. He hung suspended above the ground, struggling for his life for fifteen minutes before slowly succumbing. What's more, according to one legend, when the trapdoor opened it shattered the viewing glass, allowing visitors to hear Snowden's death throes—sounds they likely did not easily forget.

It is said that those same struggling sounds can sometimes be heard today when visiting the gallows. Was the phantom figure that the young man saw hanging by a noose at the Old Pen that of sick-minded Snowden?

A number of paranormal groups have conducted investigations inside the facility, including the team behind the Travel Channel's *Ghost Adventures*, which recorded

a number of EVPs and strange images on their cameras. In those same paranormal circles, many people over the years claimed to have been physically touched or scratched while in the building, and phantom voices or footsteps have readily been heard. Visitors often say they've been unnerved and oppressed while in the facility, especially when visiting the solitary confinement and maximum-security cells.

Considering the type of people who inhabited the building, and the stress, trauma and emotion they displayed while here, it is only fitting that it be haunted by its history.

Several other infamous people in Idaho history were imprisoned here, including Lyda Trueblood (otherwise known as Lady Bluebeard), who was believed to have murdered her young daughter and several husbands for their life insurance premiums; and Harry Orchard, accused of killing former Idaho governor Frank Steunenberg.

"Harry Orchard, who assassinated a former Idaho governor, served longer than any other inmate. He was imprisoned for 46 years until his death in 1954," read the Hillinger article.

> *He was 88. Orchard is buried in the penitentiary cemetery with 74 other inmates whose bodies were never claimed by relatives or friends.*
>
> *In the penitentiary archives are oral histories from guards, prisoners, wardens and staff. Idaho State Electricity and Transportation Museums are located in two of the old stone buildings, and the 19th-*

Century Bishops' House, for years official residence of Episcopal bishops in Boise, has been moved from its downtown site to the penitentiary compound.

Ironically, on the grounds where men and women were once held prisoner to protect the public, parties, weddings and celebrations now take place—in the Bishops' house.

Part II

ANCIENT TIMES REVEALED

Chapter 6

Uncovering the Hagerman Horse

1928, Hagerman, Idaho: What is that? the rancher wondered as he stared down at the white bone-like objects in the dirt. His pickup truck stood idling not far away, and the man looked around. Cattle grazed on his property, some staring at him as he worked the field. He turned back to the find, reached forth his hand and rubbed the dirt away. Yes, that's what they were: bones. I know my cattle, he thought, but these bones don't look like they belong to any bovine. Maybe, his mind continuing to work, he should have someone else take a look at them. Who knows, maybe his property held clues to an ancient past...

3.5 million years ago in the same place: They ran in the breezes of the tropical climate, their hooves clip-clopping along at high speed, the breeze tugging at the short mane of hair that flopped atop their heads and along their necks. After running for a while, the animals began to slow until they finally came to a stop. Now they were in the midst of other animals—some of them large, some of them small—the jungle-like forests being home to many varieties of life: the large saber-toothed cat, the hyena-like dogs, the masterful mastodon and the slow-minded

and sleepy sloth. It would have been a party if all these animals could get along, but the scene didn't hold the runners' attention for long, and they moved on. Eventually, all the animals would move, the climate would change and the only remnants of this distant past would be the fossils that would be found some 3 million years later in a place called Idaho.

It looks like something that belongs in the wilds of South Africa, not the arid deserts of Idaho. And yet 3.5 million years ago, the area's climate and geography were different than they are today. So was the local wildlife.

The Hagerman Horse is, at least locally, the most well-known animal of the Pliocene Epoch, a block of time that spans some 5.3 to 2.6 million years ago. Once upon a time, when its bones were clothed in flesh and it had lungs to breathe, the Hagerman Horse very much resembled the black-and-white striped Grevy Zebra of South Africa. It lived in a moderate climate, roamed the open country that today is southern Idaho and died only to have its bones uncovered in modern times to teach us more about Mother Earth and her ancient history.

The bones came to light in 1928 when local rancher Elmer Cook uncovered the fossils while working on his property. Having been around cattle most of his life, Cook knew what a bovine's bones looked like. The fossils he found didn't much look like they came from a cow, and he wondered

if they might have ties to another time period. Intrigued by his find but not knowing their significance, Cook presented the fossils to Dr. H.T. Stearns of the U.S. Geological Survey. The bones in turn caught Stearns's attention, and before long, he presented them to another professional, this time Dr. James W. Gidley of the Smithsonian Institution. It was determined that the fossils were indeed from another epoch, one that existed some 3 million years earlier.

And yet there was something familiar about the bones; they were part of the Equus family, "the genus that includes all modern horses, donkeys, and zebras," according to information on the website of the National Park Service, which manages the Hagerman Fossil Beds National Monument in south-central Idaho. Being part of the equine lineage, and because of where they were found, it did not take long for scientists to name the fossils as belonging to the Hagerman Horse. They were the oldest fossils of Equus found in North America, and today the Fossil Beds has the largest collection of Hagerman Horse fossils in the country. Around thirty complete and some two hundred incomplete fossils of the horse have been discovered in the area.

Today, there's a small museum and visitor center in downtown Hagerman, and in the middle of the showroom stands a stately fossil replica of a complete Hagerman Horse. On shelves and in cabinets around the room are replicas and information on other significant fossil finds, such as the saber-toothed cat, a type of sloth and wooly mammoth.

THE BURNED-OVER DISTRICT

Mother Nature, a tried-and-true firecracker if there ever was one, has a way of weeding and refueling the landscape. Many times throughout its past, the area in and around the Fossil Beds in the Hagerman Valley has been threatened by fire, including a large blaze named the Long Butte Fire that broke out in the summer of 2010. By August, it had burned "at least 75 percent of the park's 4,351 acres," according to information provided on the National Parks Traveler website.

"According to a preliminary assessment, the fire spared the Hagerman Horse Quarry, a National Natural Landmark and one of the six most important sites in the world regarding the fossil history of the horse," read an August 26, 2010 article on the National Parks Traveler website. The article continued, "Other paleontological sites and sections of the Oregon Trail were burned, and until visitor safety and resource protection can be assured, the monument will remain closed." A makeshift fence was installed around the burned area, preventing visitors from trampling the fields where new growth replaced the burned brush and grasses.

In 2014, the beds were again threatened with burning while firefighters fought five separate blazes in the area late that June and early July.

As a precaution to those who visit the area, please do respect the property and the management signs posted. They're for your safety and the protection of this historic land that could very likely have much more to tell us in the way of its ancient past.

Chapter 7

LAND OF THE ANCIENT ONES

This is the land of the ancient ones," says Gary Stone, sitting in a cave on property he owns east of Dierkes Lake in the Snake River Canyon.

The cave is one of many canyon sites that seem to tell a little something about the people who once inhabited the area. Stone claims some of those people predate history.

He walks out of the cave and says, "You can feel the spirits here."

The land is nestled on a spread overlooking the Snake River, where there is plenty of sagebrush and rock.

"Every rock is a tool—a hammer, an ax head," Stone says, picking up a small rock.

Several years ago, Stone was visited by members of the Northern Shoshone, Paiute and Shoshone-Bannock tribes, who told him the thirty acres he owns was a special place for "the ancient ones."

"Maybe a hospital of sorts," he says reverently. "This place was very special to them, a place of healing."

Stone then leads us (myself and three others) to two large slabs pushed together in a triangular shape. Inside are more large rocks that form a bench. He crawls inside, and I follow. As we sit in the tight confines, Stone explains how he believes it was used by the ancients as a sauna.

Nearby, he shows us a large rock resembling a turtle shell. It's hollowed out with a chimney-like spout on top. Stone says it likely was used as an oven.

Stone and his wife, Beverly, are known locally as storytellers and artists who've involved themselves in a number of projects to preserve Magic Valley history. They've published a number of books, including one about the Oregon Trail. Stone also has dabbled in archaeology.

He talks about the rocks, how the former inhabitants of the area might have lived, what he wants to do with the land and his belief in the supernatural. "We maintain the spirits down here. If you do anything they don't like, they'll let you know," he says, noting that some visitors claim to have seen apparitions.

He wants to make money, he says, but aims to preserve the land as well. He's thinking tours, maybe have visitors start with a boat ride up the Snake to a place of stairs, which will lead them to his spread where they'll be shown the historical traces of the Chinese and Indians who once lived here.

No, not Indians. "Remember," Stone says, "we're going back before the Native Americans."

He tears a twig from a skunk bush, pulls out a pocketknife and whittles. He says the ancient ones likely made arrows out of the same type of plant.

"Here, you can keep this," he says, handing me the half-completed arrow point.

"Want to see another cave?" Stone asks. We follow him along the very edge of the canyon rim, a small trail that strains the ankles. On the other side, far below, is another layer of rock and brush followed by the glistening green of the Snake.

I watch my feet, careful not to be distracted by the video camera I'm carrying. I look up, only to see that Stone has vanished. I hear his voice and continue walking.

Stone is sitting in another cave—a much smaller one this time—above large rocks on the side of the cliff. My notebook is tucked into my back pocket, but I have a camera around my neck, a video camera in my hand and I don't climb. He tells us how there are hook-like features inside the cave, something perhaps to hang meat on.

On our way back, Stone is eager to point out other interesting things on his property, such as the towering cliffs where there appear to be more small caves, some of the rock walls colored black as if once burned by fire. Stone surmises they were campfires used by the ancient ones.

He and Jim Schouten, one of the people on tour this Friday in late October, talk about how it might have been way back when. Did the ancient ones use the caves as shelters from inclement weather, as places to stalk their prey or to hide from their enemies?

"Possibly, there could have been 150 people to live in that wall," Stone says.

Schouten mentions the Chinese, who also left their imprint here in more modern times when they came to work on the railroad and in the mines. Chinese, in the 1880s, made up about 33 percent of Idaho's population. Could this all be from them?

Jim Woods, professor of anthropology at the College of Southern Idaho, toured Stone's property several years ago and agrees there are some interesting things to behold.

"There was a lot of occupation by the Chinese," he says in a separate interview. "They were scattered all throughout the canyon. We run across their remnants all the time; there's definitely evidence of that."

As for the ancient ones, that's something Woods isn't ready to stake his reputation on. "If someone goes in with a trained eye, an archaeologist, I'm very confident they would find things," Woods says. "It's just that I haven't found things myself."

Woods says he has his doubts, for instance, about the age of the hollowed-out rock. "Right now there's a lot of assumptions and hypotheticals," he says. "But I'd be surprised if archaeologists didn't find something on Stone's property."

He confirms there have been excavations on land not far from Stone's, such as the Pence-Duerig cave, with findings that date from six thousand to twelve thousand years ago.

Stone walks ahead, while Schouten and I stop to talk. Schouten gives it some thought.

"There could have been a civilization that lived here," he says, noting that he used to work as a guide for Thousand Springs Tours. "I've explored this canyon from CJ Strike to American Falls. There are other areas in question. There's a lot of history.

"I like the way he's preserved it," he continues. "We need more people who preserve spots along the Snake River, before we don't have them anymore."

His wife, Lori, looks around, considers what Stone has told us. Even if he's off base about the ancient ones and their spirits, she says, it's still a lovely piece of canyon land.

"I'm not too much into the supernatural. I like the geologic aspect of things," she says about the property. "It is beautiful."*

*. This article by the author originally appeared in the November 11, 2010 issue of the *Times-News*, titled "A Sacred, Silent Land: Kimberly Man Claims 'The Ancient Ones' Once Lived on His Property." Reprinted with permission of the *Times-News*, copyright 2010.

Part III

MISSIONARIES AND PIONEERS

Chapter 8

Idaho's First Book and Its First Spud

It's been said that dog is man's best friend, but in Idaho, things are a little different. Man's best friend in the Gem State is the Idaho spud, that high-in-carbohydrates tuber made famous for its heavenly fries, baked goodness and mashed masterpieces. Or, at least that best-friend perception is had among non-Idahoans. They think that everyone who lives in the country's forty-third state has a crop of potatoes growing just outside his or her backdoor.

Though the Idaho potato—something I like to call a "starch bomb"—is known the world over for its gregarious girth and many dimples, it is interesting that many parts of the state are better known for their alfalfa and sugar beet farms and dairy operations than anything spud related.

If you're a spud fan—one of those iconic people who prefer mashed potatoes with their pot roast or baked potato with their steak and will not at all turn down a french fry at any cost—then you might be interested in learning the

genesis of the Idaho potato. We can rightly say it started with Henry Harmon Spalding, who with his wife, Eliza, planted that first spud in 1837, soon after arriving in the territory as Presbyterian missionaries.

Of Spuds and Spaldings

The Spaldings came to the territory in search of converts, hoping to bring Christianity to the area's Native Americans, and so they established the Lapwai Mission near present-day Lewiston. The mission was to teach the Indians not only of Christ but also, as the white man thought at the time, practical skills that could help them become a more refined people.

Enter the Idaho potato, which besides being a filling meal unto itself was used as a teaching tool at the mission. Taking plow to field, Henry Spalding planted the first potato in Idaho in 1837, cultivated it and, eventually, reaped the harvest, proving to the Indians that it was indeed possible to grow such food.

Thank the Spaldings for planting that first spud, but it was another band of religious zealots, Mormon settlers in eastern Idaho, who planted a full crop of the tubers. But according to an article in the *Times-News*, "The roots of Idaho's famous potato, the Russet Burbank, go back to 1872 Massachusetts, where a young gardener experimented with the Early Rose potato."

More history about the Idaho potato: "Luther Burbank, who would become the 'father of modern horticulture,' nurtured a particular seedling, which produced three times the tubers of the average potato. He sold the variety to a man who dubbed it the Burbank potato," reads the article. "A mutation of the variety was cultivated 40 years later in Colorado and became known as the Russet Burbank.

"Idaho's climate of warm days and cool nights provides ideal climatic conditions for growing the famous bakers, so while most say the Russet Burbank made Idaho famous, others say Idaho made the Russet Burbank famous."

According to the Idaho Potato Commission, "Idaho's ideal growing conditions—the rich, volcanic soil, climate and irrigation—are what differentiate Idaho potatoes from potatoes grown in other states. While the russet is the most well-known potato grown in Idaho, more than 25 other potato varieties are grown in Idaho including: Yukon Golds, Reds and Fingerlings."

PRINTING IDAHO'S FIRST BOOK

While among the Lapwai Indians, Spalding and his wife accomplished many firsts in the territory, including printing the West's first book. Spalding, an innovator and entrepreneur if there ever was one, also established Idaho's first school and the area's first irrigation system—the latter becoming a boon for generations of farmers and potato lovers.

As for the book, take a wild guess at what it was that Spalding printed. You guessed it: after he established a mission among the Lapwai, the ambitious, creative and entrepreneurial-minded Christian missionary printed the Holy Bible.

It's been said that 1837 held another first for Idaho: the first white child was born here. Guess who the parents were. Yep, the Spaldings.

One other item of note: Spalding's wife, Eliza, not one lick behind her husband, also accomplished a first; she and missionary friend Narcissa Whitman were the first white women to cross the continental divide. They did so after leaving Missouri on their famous trek west. The members of the Whitman-Spalding group were the first people to make the journey on what later would be called the Oregon Trail.

As a missionary and comely gentleman, and for printing the first book in Idaho, Spalding was a righteous dude, one who deserves our gratitude and respect. And as for planting that first potato in Gem State soil, giving us the famous tubers of today, he might not have been much of a stud, but in the coolest of terms he was definitely the territory's first Idaho spud!

Chapter 9

Tempting the Snake River: Caldron Linn

The mighty Snake River has tempted man, both his courage and his nerve, ever since he encountered it long ago while exploring the arid West. One of those men was Wilson Price Hunt.

Hunt led an exploratory party from St. Louis, Missouri, to Astoria, Oregon, beginning their journey on April 22, 1811, as part of the Astor Expedition, named after its financier, John Jacob Astor. The goal of the expedition was to map a water trail to the Pacific Northwest, traveling by waterways most of the way and using information from the Lewis and Clark Corps of Discovery Expedition to make parts of the journey. When Meriwether Lewis died in 1809, Astor hoped to make his pitch for governor by proposing a solution with his proposed route west. Among his plans was to create a business empire that would control the growing fur trade industry and extend it to the Pacific Northwest—an ambition not welcomed by North West Company and the Hudson's Bay Company.

When Hunt, a St. Louis businessman, was chosen as leader of the expedition, it was in some ways ironic in that he had little to no experience in extreme outdoors. He proved successful—despite many of his decisions being considered wrong and even disastrous—and his party reached the Columbia River less than a year later, in February 1812. Before they reached the Columbia, however, they encountered the Snake River in southern Idaho—and the Snake bit back.

The Native Americans were the first people to encounter the Snake, some ancient tribes living near the water source or in the canyon by the same name. In the 1800s, it was a river new to the white man. The river stretches from the Teton Valley in Wyoming to the mouth of the Columbia River in Oregon; more than four hundred miles of it wind through Idaho. Portions of it are placid and serene, while other parts are tumultuous and frenzied.

Frenzied is a good term to describe a place on the Snake called Caldron Linn, near present-day Murtaugh. Hunt's party first encountered water gentle enough to traverse, but, as does happen upon the Snake, it later turned vicious.

The mighty Snake River, an expansive width, at Caldron Linn narrows to fewer than forty feet. Water gathers in a pool before being forced through a narrow opening and cascading to a tumultuous bath over the cliffs, where the river again picks up through a rocky portion.

Hunt and his party, after traveling for nine days on the river, tried maneuvering through this distressed portion

but to no avail; boats capsized, and one man lost his life. That forced Hunt and his party to ground their canoes; he then divided the men into four parties, and they started the boots-on-the-ground trek that took them to the mouth of the Columbia River. Each of the four groups would take different routes to reach the Columbia.

Caldron Linn, also known as Star Falls, is today one of many majestic and iconic sites of the Snake River. It was added to the National Register of Historic Places in 1972 for its historic role in the Hunt expedition. The water is fullest during summer, with sometimes almost no water making splashes here during the off-season.

"To get to the falls, created by the Snake's forced passage through an area less than 40 feet wide, visitors must first meander around towering sagebrush and river rock scattered along the land," writes Blair Koch in the May 6, 2009 issue of the *Times-News*. "But a well-worn dirt path makes it easy to explore. All along the path the falls offer a roaring welcome. Before you know it the sagebrush gives way to the canyon rim—and then, Caldron Linn. Mist soars as the river slams the towering basalt."

Koch also gives this warning: "Visiting Caldron Linn isn't for the weak of heart, and it is imperative to keep your children secure: the falls aren't developed, there is no safety rail or concrete walkway along the falls. Using caution, common sense and wearing hiking shoes are important. You won't find a parking lot, entry fees or a waiting line at Caldron Linn, but you just might find plenty of adventure."

When visiting the site today, be sure to bring a camera, as it offers a scene you won't want to miss. But even then, pictures do little to truly capture the malevolent yet majestic wash that reminds one of a witch's stewpot, a whirling and chaotic caldron.

Chapter 10

RIVIERE AUX MALADE

The men, all of them fur trappers, were tired, worn and hungry. A nice venison steak sounded just fine, but fat chance of them finding any deer around these parts of the river. There was another choice: rodent meat or, more precisely, beaver—the world's largest rodent. They killed the animal, roasted it on a fire and sated their hunger. Or so they thought, until their stomachs took a turn for the worse, the meat having not agreed with them. Vomiting, diarrhea—all of those nasty things that make being sick a sickly experience—rushed upon the fur trappers and weakened their bodies. "Damn beaver!" they exclaimed vehemently. "Damn sickly river!"

Many marvels of nature exist in south-central Idaho, where famous waterfalls, iconic rocks, underground springs and deep canyons dot the landscape. One of those canyons, sculpted from the hand of Mother Nature, is Malad Gorge

off Interstate 84 near Hagerman. Webster defines a gorge as being "a narrow passage through land…a narrow steep-walled canyon or part of a canyon."

Malad Gorge is such a place. Besides its interesting display of geology, it also has interesting episodes of history associated with it.

Donald Mackenzie, a Scottish Canadian trapper, led a party through the area sometime between 1818 and 1821 as part of the Wilson Price Hunt party. It didn't turn out to be a very pleasant experience. Several of his men became ill while camping in the area. They determined the cause of their illness was the river, and so they named it "Malade," a French word meaning "sickly." But Mackenzie's sickly river, it later was determined, was not the culprit after all.

Sometime between 1832 and 1835, mountain man Jim Bridger led another group to the area. His men also became ill, but from beaver and not the river itself. Beaver, the world's largest rodent, would digest poisonous roots from a certain tree in the area. The roots apparently had no effect on the animals, but they wreaked havoc on Bridger's men after they ate the beaver.

This Malad River gets its life as a confluence of the Big Wood and Little Wood Rivers near Gooding and travels just twelve and a half miles toward Hagerman, where it meets up with the Snake River. Before its destination, however, water runs through a narrow passage, falling some 250 feet into a whirling pool popularly called the Devil's Washbowl. You can almost envision Satan on the banks of the river, a

smile on his crafty face as he plunges a pitchfork into the misty pool trying to keep his clothes under water.

There are, in fact, a lot of things you can imagine here, for the place and its river have indeed seen some interesting episodes during their lifespan. It is said that in the 1800s, bands of outlaws found the deep ravine of the canyon a good place to hide from lawmen who came searching for them. The canyon has plenty of large rocks and small caves, perfect for hiding. It is rumored that some shootouts

took place here, but viewing the gorge today makes one wonder how—or at least why—people would want to explore or hide inside the canyon itself. It is a deep, rugged and cranky-looking canyon that doesn't appear too friendly to those who'd try to explore its depths.

The park to which it belongs is another matter. Malad Gorge State Park is a friendly place that is open all year. The site has picnic tables and trails and is a good place to view wildflowers in the summer. For a nominal fee, you can stop by to take a quick peek at the famous gorge or spend several hours here with a picnic basket and camera. A narrow bridge takes visitors across the gorge, allowing them to stop 250 feet above the canyon floor to view the Devil's Washbowl.

When you take a gander, see if you can imagine ole Lucifer down there—way, way down there—with his pitchfork and devilish grin. Maybe it's not clothes he's stirring in the bowl, after all, but beaver meat and some of that poisonous weed from the river.

Chapter 11

THE WRITING ON THE WALLS

First scenario: they had traveled hundreds of miles over rough and rocky landscapes, through desert and mountain climes, and had fought hunger, thirst, fatigue and the burning rays of the sun. The shade they now encountered among the rocks, a place the Indians knew well, was a welcome relief. They wanted to mark it, write their names for others who passed along the California Trail. And so many of them did, dipping their crude instruments in axle grease and registering the rock with their names and initials.

What are millions of years old and stand six hundred feet tall? If you guessed Idaho's oldest and largest potatoes, you'd be…wrong.

The correct answer: the giant monoliths at the City of Rocks National Reserve near Almo, not far from the Idaho-Utah border. If you're a rock climber or nature explorer,

chances are you've already visited the park. People come from all over the country to climb its rocks and walk its trails. The site, managed by the U.S. National Park Service, draws more than eighty thousand visitors a year.

With its granite spires that date between 28 million and 2.5 billion years old, the latter-dated rocks housed in the Green Creek Complex, the park is an interesting study in geology. Some of the spires reach six hundred feet toward the sky. The rocks here came about through an erosion process called exfoliation, basically the loss of rock plates and scales.

Second scenario: the men held the knapsacks tightly to their chests, fearing that if they didn't the sacks would easily fall to the ground or, worse, into the clutches of stalking Indians or others who wanted the loot they contained for themselves. The sacks were filled with gold and other precious commodities mined from the California ore fields. Of course, these men didn't glean the fields themselves, but plundered the stagecoaches that came through the area with their gold and other precious metals.

Here, in the shadow of the towering rocks, the looters would rest and hide their stolen goods. But to keep their precious metals safe, they'd find a place of safekeeping, someplace other than the packs on their horses or in their wagons. Earth was the answer.

Holes were dug, their treasures deposited and covered, the sites marked by a rock or two, something that would allow the owners to

rediscover them easily enough. But as things happen in this land of mystery, where the very rocks themselves seem to change shape, the makeshift graves were misplaced and forgotten. The owners, after frantic searches, left unsettled and angry, their loot left behind and, apparently, consumed by Mother Earth.

While the City of Rocks today serves as a modern recreation spot for outdoor enthusiasts, there are layers upon layers of history at the site. In the 1800s, the rocks "marked the progress west for the emigrants and, for their loaded wagons, a mountain passage over nearby Granite Pass" along the California Trail, according to the National Park Service website. "Early emigrant groups were guided by experienced mountain men such as Joseph B. Chiles and Joseph R. Walker. Later wagon parties followed the trails themselves, perhaps with the diary accounts of previous emigrants."

Not only did pioneers keep paper journals, but many also left their marks on the very rocks themselves. Their messages—most just initials—were left in axle grease on Register Rock and are still visible today, as are ruts caused by wagon wheels in some of the rocks. Travelers on the Salt Lake Alternate Trail and freight routes from Kelton, Utah, to Boise also would stop here to rest themselves and their animals. It is believed that the site, though known about by early 1800s fur trappers, was ignored by the white man until around 1843, when the wagon trains began to travel through

the area on their way to California. Before that, the Shoshone and Bannock tribes hunted bison in the area and would often come here to camp. By 1852, however, it was estimated that more than fifty-two thousand people passed through the City of Rocks on their way to California's gold fields.

"After 1850," reads the website, "the Pass became part of Utah Territory, and in 1872 an Idaho-Utah boundary survey error placed Granite Pass in Idaho Territory. With completion of the transcontinental railroad in 1869, the overland wagon routes began to pass into history."

Settlers began to homestead the vicinity in the late 1800s. Though dry land farming declined during the drought years of the 1920s and 1930s, ranching survived. Livestock grazing in the area still continues today.

One legend associated with the site is about stagecoaches that were periodically attacked by robbers, park superintendent Wallace Keck told me when I interviewed him in 2012 for another story. The loot, sometimes gold or other precious items, was buried by the robbers to keep it safe. It is said the loot still is buried here, though Keck said it likely is an old wives' tale. No buried treasures ever were uncovered here to his knowledge.

Keck said he's not as interested in legends about the park as he is about its factual history. "We've been doing a lot of studying of the signatures [at Register Rock] along the California Trail," he said. "We've found that the facts are every bit as exciting as the myths."

Chapter 12

Saving Her Furniture

Firefighters have been known to risk their lives to save a person or pet from a fiery blaze, often being termed heroes after such escapades. In late 1800s Idaho, one petite woman showed the same courage in an effort to save her furniture. Her name was Lucy Stricker.

Lucy Walgomot came to Idaho in 1879 and settled at Rock Creek Station, south of present-day Hansen, where she met her future husband, German-born Herman Stricker. The station, named after the small creek that runs through the area, was established in 1864 when Ben Holladay chose the site for his Overland Stage Line, which stretched from Salt Lake City to Walla Walla, Washington. A small supply store was built a year later, and eventually a small town blossomed in this spot in the arid West. Herman and Lucy would play pivotal roles in the growing history of the area, and their famous homestead still stands today as a landmark along the Oregon Trail.

Lucy and Herman courted until 1882 before tying the knot and making a small log cabin at the station their home. Lucy tried to make the place cozy for her husband, but the place was hardly large enough for their growing family. Fate intervened when a fire broke out at the house when no one but Lucy was home. She went into the house and dragged her bedroom furniture out one piece at a time.

The Strickers later built a larger ranch house not far from their first, and it is this house constructed in 1901 that today is listed on the National Register of Historic Places. The story of Lucy saving her furniture, little known in Idaho history, is locally retold to those who visit the old-style ranch house today, where black-and-white photos of Lucy and Herman hang from walls, their ghost eyes staring from the milky film of decades past.

If you haven't yet visited the site, it's not too late to do so. The home is open for guided tours every Sunday from Memorial Day through Labor Day, and it is at these times that you likely will hear about the many oddities from the site's past. Also, visitors may stop by the property all year for self-guided tours along the trail—as long as it's before the sun sets. Because it is a historical site, trespassers are not welcome after dark.

Remnants of the Past

But the ghosts are welcome—err, at least they don't abide by any curfews.

Stricker Ranch is a favorite haunt in Idaho's Magic Valley. It also is one of the places deemed most haunted in the area and has many ghosts—or at least ghost stories—associated with it. The organization that manages the property, the Friends of Stricker, shrugs at such suggestions, but those who know the site best say there is something of the past that remains. Gary Guy, the caretaker at the historic property, says he's had many experiences with the paranormal since arriving on site in early 2010. He spoke with me about some of those experiences for my book *Ghosts of Idaho's Magic Valley*. One of the more memorable experiences he's had happened one night while sleeping in his bed at the guesthouse, attached to the old white and green clapboard. Guy says that he was awakened one night by a ghost's touch:

I felt a hand on my shoulder, and I woke up immediately. I was trying to think what is going on here. I was lying there, listening to the room, and all of a sudden my light comes on. It just popped on. By this time I'm starting to get a little anxious...So I get up and look out the window, and there are about eight people out front. This was about 1:30 in the morning. I really wasn't thinking at the time, otherwise I probably wouldn't have done what I did, but I came out and said, "The site is closed and dark and you really shouldn't be here, and so if you would, I would appreciate it if you'd vacate the premises." And they started acting like they wanted to give me some flack, but there was one lady there, and I sort of directed my attention to her, and I said, "I've already called the sheriff's department; they'll probably be here in about ten or fifteen minutes, so I'm asking if you guys would leave." And she said, "C'mon guys, let's go." And they jumped in their pickups and took off. I went back into the house and was thinking about the sequence of the events.

Lucy took great pride in her new home, built in 1901, and liked to entertain guests, often throwing parties in her stately ranch house. She had two doors installed in her parlor. One was a door that exited the house; the other was a sliding door that separated the home's parlor from the rest of the house. It was in the parlor where Lucy held her parties. When the doors were closed, that's when the parties

began. That was Lucy's time, Guy said. She was always finicky about her home and yet often opened it up to her friends and the immigrants. Laughter and lightheartedness were showcased here, the sounds of life floating through the home and outside.

Unfortunately, the property saw its share of sadness too. It is said that several immigrants, including a few children, died on the property in the late 1800s because of illness. Workmen succumbed to death due to accidents, and there are reports of at least one murder that happened on the property in its early days. All of these instances could cause paranormal occurrences but perhaps none of them as much as the emotional ties that Lucy developed to her property.

Portraits of Lucy and her husband, Herman, today hang in the home's master bedroom, which sits off the parlor. Their eyes, colored black and white in the old photographs, seem to take careful stock of their home's guests. Though the couple is deceased, there's something of their spirits, especially of Lucy's, that seems to remain.

Guy's experience with Lucy wasn't the first paranormal episode he's had in the house, nor his last. After my book was published, I met again with the white-haired caretaker, who told me of an experience he had shortly before my return to the old homestead. He walked outside to work in the yard one morning, he said, and came face to face with a young girl in a white dress. She didn't stick around for long, however, before quietly slipping back into the spirit world from whence she came.

Not long after arriving as its new caretaker, Guy said the unseen inhabitants of the house liked to play tricks on him. After he'd shower, he'd leave the shower curtains closed so they could dry. When he'd return to the bathroom later, he'd find them pulled fully open. It happened about three different times, he said, and then the incidents quit. The spirits also seemed to like his tea.

One afternoon, he fixed himself a kettle of tea, filled a mug of the hot drink and then left the kitchen to let it cool. When he returned a few minutes later, the mug was half empty.

Chapter 13

THREE ISLAND CROSSING

One of Idaho's historic treasures is the Oregon Trail, otherwise known as America's Overland Route, of which a part winds its way through the Gem State. Time, Mother Nature and, in some instances, the careless acts of humans have caused the trail's imprint to diminish over the years.

Steve Davis, a teacher of history at Canyon Ridge High School in Twin Falls and a self-proclaimed Oregon Trail enthusiast, has been exploring the historic trail for years and says it is important that people understand what a significant thing it was in the making of the West. He doesn't want to see the trail fade into oblivion, little understood by the rising generation.

The Oregon Trail was, in fact, not one trail but many—thus, perhaps the more proper name should be "Oregon Trails." While many thousands of emigrants followed the main stem to the Pacific Northwest, many

other emigrants, such as the Mormons on their way to the Salt Lake Valley or those wealth-seeking folks heading to the California gold fields, used the main trail so far only to break off to their various destinations. There were also other routes, such as the Pony Express and the Stagecoach Trail, that often used parts of the larger Oregon Trail. Because there are so many diversions and routes, it is easy to become lost when first studying the topic of the "Oregon Trail." But that need not be the case, and for our intents and purposes, we'll keep it simple.

In 2010, I wrote a two-part story for the *Times-News* about the trail in southern Idaho and met Davis on the trail near Hagerman, where amidst a late afternoon breeze, we chatted about the historical significance of the overland route:

> *"I don't know how they did it," Steve Davis said as he looked out over the rugged landscape that is the Hagerman Valley.*
>
> *Like weeks before at Stricker Ranch near Hansen, the wind was blowing on this Friday in mid-June.*
>
> *That wind, coupled with the occasional song of a meadowlark and the din of our own chatter, were the only sounds along the Oregon Trail.*
>
> *The voices seemed odd, out of place among the desolate setting where bitterbrush clung to our heels as we talked about the pioneers and their journey West.*
>
> *"I don't know if I could have done it," Davis said, admitting the pioneers must have possessed an*

endurance deep in their guts that many people perhaps today do not have.

Here, in south-central Idaho, more than 1,200 miles from Independence, Mo., where the trail began, the fear of Indian attacks and rattle snake bites were common fare among the pioneers. Disease was even more common, Davis said.

Cholera was perhaps most deadly, especially in 1849–50 and 1852, according to author William E. Hill. Some emigrant companies reportedly lost two-thirds of their members, while others lost only a few.

On their way to Oregon, migrants had many benchmark stops where they'd rest and refresh themselves and their animals, including Salmon Falls, not far from where Davis and I met in June 2010. The Falls received its name because of the abundant salmon population of the area. Here, Indians would catch fish with their hands and spears, Davis said, and would trade them with the pioneers. A migrant named Overton Johnson observed that "the Indians take immense quantities of Salmon, which they cut into thin slices, dry in the sun, and afterwards pack them in grass cases."

Later, along the Emigrant Tail, the pioneers would reach present-day Glenns Ferry, a place where the Snake River is checkered with three small islands. Here, the emigrants had a choice: cross the river, or at least attempt to do so, or stay on the dry and rocky alternate trail that rejoined

the main stem at Fort Boise, some ninety miles northwest. Many chose to stay on dry land, while others wanted to shorten the distance by crossing the green waters of the Snake. They did so by "island hopping," something the Indians in these parts had been doing since long before the white man appeared. The natives guided the emigrants to the shallowest route from one island to the next until they had crossed the river. Information at the park's interpretive center explains the three islands served as steppingstones for the pioneers until they reached the north side.

Most crossings were attempted in late July or early August because the river was only two to four feet deep, according to information at Three Island Crossing State Park. "At times of higher water, wagons were caulked or ferried here or at the two island crossing upstream," reads an interpretive sign at the park. One pioneer, William T. Newby, described the experience of crossing the river by writing in his journal on September 11, 1843:

> *First we drove over a part of the river one hundred yards wide on to a island, the*[n] *over a northern branch 75 yards wide on a second island; then we tide a string of wagons together by a chane in the ring of the lead cattles yoak & made fast to the wagon of all a horse & before & him led. We carried as many a*[s] *fifteen wagons at one time…The water was ten inches up the waggeo*[n] *beds in the deepe places.*

Island hopping was done until 1869, when Gus Glenn built a ferry to transport emigrants across the Snake, giving Glenns Ferry its name. So significant was the horse-and-wagon crossing that for several years reenactments of it were done every summer until they were canceled in 2009. According to an October 14, 2009 report by news station KTVB:

> *Not enough horses on hand is forcing the end of an Idaho tradition that has gone on for nearly a quarter of a century—the Three Island Crossing.*
>
> *For the past 24 years volunteers have reenacted the crossing of the Oregon Trail by pioneers in wagons.*
>
> *Volunteers say another factor in the cancellation is that participants are getting too old for the dangerous maneuver, and they are having trouble getting younger riders to take the reins.*

As for Davis, he said Three Island Crossing State Park is one of his favorite spots along the overland route. "For me it's perhaps the most tranquil and one of the most beautiful places along the trail," he said.

Chapter 14

Massacres, Drownings and Water Babies

There are several stops along the Oregon Trail in Idaho, and one of them is Massacre Rocks near present-day American Falls. What makes this an intriguing place to learn about is, first, its name. Sadly, it was named after a real massacre that occurred here in 1851. It went like this:

Emigrants traveling the Oregon Trail had to rest and refresh themselves, and they'd try to choose the safest places to do so, away from Indians who, during those times, often would attack caravans in the open West. Sometimes, however, the emigrants had little choice in either trail segments or rest stops. The tragedy that befell five wagons at the place now known as Massacre Rocks attests to this fact.

When the emigrants encountered the place of rocks—today a state park that has more than nine hundred acres, many of them decorated with large boulders and monoliths that were created during repeated volcanic activity of the Snake River Plain some 14,500 years ago—they called it "Devil's

Gate" or "Gate of Death" because they feared they could easily be ambushed by the natives in such a secluded area, the rocks giving the Indians great places to hide. On the other hand, the rocks provided shade and shelter from the weather for the emigrants, and so the site often was a place where the emigrants camped while on their way to Oregon or other points west. They left something of themselves behind: many of their initials or names have been found painted on the rocks.

It is unverified if any skirmishes did indeed take place among the rocks, though it is believed the conflict that killed ten emigrants from four wagon trains and several members of the Shoshone tribe on August 9–10, 1862, took place just east of the rocks. About eleven years earlier, in 1851, another violent incident, called the Clark Massacre, took place just west of the present-day park.

It makes sense how the park received its name, however unpleasant. It is a name that strikes uneasiness and dread, but such feelings need not be entertained when visiting the family-friendly park today. It is a favorite recreational stop for many people, as you can find many activities to keep you busy here such as camping, canoeing, fishing, hiking, mountain biking and exploring among the rocks. Keep an eye and ear out for snakes, as rattlers have been known to slither here, and do bring a camera because it is a place of contrast and rough beauty and photographers always find new angles and perspectives through their lenses while exploring the park.

You won't be able to travel the exact route of the emigrants because their passage through the rocks, at the southernmost edge, is now Interstate 86. If you're attuned to the supernatural, however, it is said you could encounter the sad, agonizing cries of the deceased as they're carried on the wind. Some of them might sound like young children, as there's yet another grim story associated with the site.

Long ago when the Indians inhabited the area, as the tale goes, a severe famine struck the land, wreaking havoc among the tribes. So distressed were the individuals and families that it was decided new additions to families—babies born during this trying time—would have to be quickly dispatched because of the lack of food. Mothers were forced by tribal leaders to take their newborn babes to the river, where they'd hold them under the water until they stopped breathing.

Chapter 15

A Brief History of Fort Hall

No one knows for sure, but it's been estimated that more than 100,000 people traveled America's overland route, the Oregon Trail, between 1841 and 1869. The 2,100-plus-mile route started in Missouri and stretched to the Pacific Northwest. Emigrants fleeing their old lives in the Midwest embarked on the trail in search of new lives in the West. Most went to Oregon, but some parties broke off from the main trail stem to head to other points west, such as Utah or California.

One popular stopping point along the way, as recorded in my book *Haunted Idaho*, was Fort Hall, located in Bannock County in southeast Idaho. It was established in 1864 by the Fort Bridger Treaty between the United States and Shoshone-Bannock tribes in the wake of the 1863 Bear River Massacre. In that bloody conflict, more than four hundred Indians were killed by army soldiers. It was a sad day in the history of the United States and Idaho, but the

tragedy was the culmination of a long, continuing struggle between Indians and the white man.

In the 1850s, for instance, Chief Pocatello commanded attacks on emigrant parties, in part, because they were encroaching on their hunting grounds. Things never quieted down between the factions, and in 1863, U.S. Army colonel Patrick Edward Connor led his troops from Fort Douglas, Utah, to Fort Hall to "chastise" the Shoshone. Pocatello, however, was warned of Conner's plans and led his people out of harm's way, resulting in the attack on another band. Pocatello subsequently sued for peace and agreed to relocate his people to the newly established reservation along the Snake River.

Four bands of Shoshone and the Bannock band of the Paiute relocated to the reservation, then consisting of 1.8 million acres of land. The U.S. government agreed to supply the Shoshone-Bannock annually with goods and supplies annuities worth $5,000.

From 1868 to 1932, the reservation territory was reduced by two-thirds due to encroachment of nonnative settlers and governmental actions to take land. In 1934, Congress passed the Indian Reorganization Act, created in part to end the allotment process, encourage tribes to reestablish self-government and to keep their land bases. In 1936, the tribes reorganized, wrote a constitution and established their own elected government.

Before it became a reservation, Fort Hall was a fur-trading station that Captain Nathaniel Wyeth established in

1834. His business was short-lived, however, at least under his ownership. He sold it a year later before returning to the East.

Chapter 16

Mormon Town

All the hominess of a small town is prevalent as you walk the streets of Oakley, enter its businesses or sit in the community park. It's a quiet, historic little town.

Walk into the library to peruse its books, visit the city offices to read the town's old newspapers or chat with a lifelong resident and you might learn something about Gobo Fango, a black man who was shot in 1886 over a property dispute; or the Bigfoot character once rumored to have chased small children in Birch Creek Canyon.

A small jail that once held Diamondfield Jack today sits empty in the city park. The town's old opera house is still standing, as are many of its original Victorian houses. A number of them are listed on the National Register of Historical Places, some of them the former homes of once-prominent political and religious figures such as former presidential candidate George Romney and LDS apostle David B. Haight, both of whom were born in Oakley.

Religion has played an important role in Oakley since its inception, especially the Church of Jesus Christ of Latter-day Saints, whose members in the late 1800s founded the community that once boasted a population of more than 2,000 but today, according to a sign as you enter the historic district, has only 668.

Most of those are likely members of the LDS church, according to lifelong resident Harlo Clark, himself a Mormon.

Oakley, which sits in the heart of Goose Creek Valley in south-central Idaho, is named after William Oakley who, in about 1869, opened a Pony Express station about two miles from where the town center is located today, not far from the Utah border.

It didn't take Oakley's newcomers long to plant their crops, which in the spring of 1879 were attacked by an invasion of Mormon crickets. While no seagulls came to the farmers' aid as they did in the Salt Lake Valley, the crickets didn't shirk the settlers' faith about why they had moved to Oakley.

Clark, fifty-five, says his ancestors settled in the Oakley area after moving from Grantsville, Utah, in the late 1800s. They came, like many other Utah immigrants—many from Tooele and Grantsville—to work in the mines and, later, to help build Oakley Reservoir.

It was during the reservoir construction between 1909 and 1912 that the population grew to more than two thousand—and began to decrease once the mines closed in the late 1920s.

Clark still works in his family's grocery store that opened in about 1909 as a co-op with ZCMI, a Mormon-owned company. Some of the town's other businesses are now gone.

Besides Clark's grocery store, Oakley today has a gas station, restaurant, post office, day care, library, city offices, a museum and schools. At one time it even boasted a hospital and its own newspaper, the *Oakley Herald*.

Born April 5, 1892, in Independence, West Virginia, Charlie Brown moved west in 1917, settling in Tremonton, Utah. By January the next year, he moved to Oakley, where he bought the *Oakley Herald* from Fred Jenkins.

Brown ran the paper for the next fifty years, often doing most of the work himself. He also served for a time as president of the Oakley Chamber of Commerce. He was drawn to the area by the City of Rocks, which he helped promote over the years. A newsletter about his retirement explains that Brown "never…had any financial interest in the area, but has been interested in developing the City of Rocks because of its fascinating character."

Interestingly, Brown came to the area as a Baptist minister. He served at the Union Church but, perhaps due

to the area's Mormon influence, soon gave up the post. According to a book written by Brown and local historian Kent Hale, the minister-editor "gave up his position with the church and burned all his sermons." Years later, he was reported to have told a friend, "The resultant fire provided the only warmth that had ever been derived from my sermons."

It's easy to see Mormon influence in Oakley today. It also is easy for residents to know when a stranger arrives.

It's been rumored that the non-Mormons in the area have felt shunned by the Latter-day Saints who live there, but the consensus of those with whom the *Times-News* spoke on the streets is that most feel as if they belong.

That Oakley is a Mormon-biased town is "more perception than reality," said Kent Hale's son, Dwight. He agrees that most people get along well in the community.

"Some people might feel like we're a little cliquish, that we don't associate with others," said the town's library director, Pam Jenks. "But I think we're all mostly friends." That friendship is best exemplified when there's a crisis, she said. During those times the community pulls together, and sect membership takes a back seat.

Oakley is about 70 percent Mormon, according to Mormon missionaries Ryan Penfield and Freddy Villanueva. Others have estimated 90 percent.

The high church membership helps them as they proselytize to others because there are not a lot of misconceptions about the church, the missionaries said November 5 as they stood outside Clark's grocery store drinking soda pop.

"The church gets a great representation out here," said Elder Penfield. Oakley is a lot different than the multi-thousand-population Thousand Oaks, California, that he calls home. But Oakley is a pleasant town, he told the *Times-News*—"a good town."

Even the non-Mormons are mostly friendly to the elders.

"There's a lot of friendly people out here," Villanueva said before the elders dropped their pop cans into a trash bin.*

*. This article by the author originally appeared in the November 28, 2009 issue of the *Times-News*, titled "Mormon Town: Impressions of Oakley from an Outsider." Reprinted with permission of the *Times-News*, copyright 2009.

Part IV

HOAXES AND DARING STUNTS

Chapter 17

FOOLED BY A, UM...UFO

As one stands still on a starry night, gazing at the heavens and its myriad celestial bodies twinkling in the backdrop of darkened sky, it is easy to consider the galaxy and our place in it. It also isn't unexpected for us to wonder if we are alone in the universe or if there are others like us, on distant worlds, that live and move and have an existence.

Throughout the centuries, people have reported seeing strange lights in the sky, unidentified flying objects and alien encounters. Some people even claim to have experienced abduction; some of the experiences were reported as harmful and frightening, others benign and harmless. Some stories seem plausible, making us wonder if such tales are true, while others are easily seen as nothing more than a hoax. At other times, some hoaxes have been difficult to determine.

As the sun crawled up the eastern horizon on July 11, 1947, casting its rays across a morning-blue sky, its streaks soon to stretch across the fertile farmlands of the Magic Valley, the day promised to be as normal as the day before in the community of Twin Falls. Farmers already were in the fields, while many other professionals were at their desks or other jobs. Some residents, such as Mrs. Fred Easterbrook, stumbled to the kitchen in search of a morning meal. As she looked out the kitchen window, perhaps a yawn widening her face as she did, her eyes happened upon something odd and, by all estimation, otherworldly lying in one of her neighbor's yards. On the front lawn, as if it had crash-landed into the green turf, lay a large round object that by all appearances looked like the traditional UFO, a disc that, Mrs. Easterbrook thought at that moment, might have literally come from outer space.

Forgetting the gnawing itch of hunger that had settled in her stomach, her body was now fully awakened and breakfast was forgotten. Mrs. Easterbrook went from her cozy kitchen to the front door, opened it and stepped outside into a new day and a different kind of morning experience—to what, exactly, she didn't know. Had little ole Twin Falls, Idaho, received a close encounter of another kind?

Soon, law enforcement officials and members of the press were on scene delving into the matter, trying to figure out what the incident amounted to: Had the growing community of Twin Falls, which in 1947 had a

population of nearly seventeen thousand, been visited by an alien encounter? Or was there a more logical—and earthly—explanation for the apparent UFO? If it had been real, what a find! If it were a joke, however, boy, would someone be in trouble!

According to what was written at the time, for several days before the find, area residents had reported seeing saucer-like aircraft in the sky, buzzing over their homes. Nothing was ever confirmed as to what the object may have been—not until July 11 rolled around, that is, and Mrs. Easterbrook went to her kitchen window. The rest, as they say, is history—but not the kind that is well remembered today.

The disc, according to a period report by the Associated Press, was made of Plexiglas, radio tubes and burned wires—not items you'd expect an intelligent life form to use in a space transport that travels the vast, starry heavens.

What's more, the disc was only 30.5 inches wide. Unless their occupants were miniature creatures, more in line with Lego characters than human stature, this was clearly the work of a prankster. The truth, as it turned out, was that there was at least a couple of culprits involved, both of them teenagers, who said they had "used parts of an old phonograph, burned out radio tubes and various discarded electrical parts to manufacture their device," the AP reported. Apparently in midsummer Idaho the boys couldn't find anything better to do than pull a practical joke on their neighbors.

It was their neighbors who may have had the last laugh, however, because the joke caused a large stir among law enforcement that stretched to the ranks of the FBI.

"Assistant Police Chief L.D. McCracken withheld the names of the pranksters because they were juveniles and no court action will be taken against them," reads a July 12, 1947 report by the Associated Press. "He said they admitted the hoax after he was 'tipped' that one of the boys knew something about the case."

The boys apparently spent two days making the 30.5-inch disc, which "resembled two band cymbals put together." The disc looked real enough that, when it flew over houses, "an FBI agent took one look, notified his district office in Butte, Mont., and three army officers came post haste from Fort Douglas, Utah, in a military plane furnished by the state national guard."

The AP article continues:

> *The practical joke started the biggest wave of speculation over flying discs this town has witnessed since about 30 residents reported 10 days ago they saw the galloping discs swishing overhead. Two narrow strips of turf on the Thompson lawn were torn up as if the disc had ploughed into earth.*
>
> *Officers were puzzled at first—until the hoax was discovered—how the metal object could have sailed to the ground through the maze of overhead telephone and power wires.*

Mrs. Easterbrook, the Thompson family and neighbors in receiving events last night, speculated today that they heard a "thud" during the night—probably about 2:30 a.m. But the boys told police they planted the disc about 10 p.m.

A plane load of army officers—two lieutenant colonels, two first lieutenants and a civilian—arrived in a Utah national guard plane shortly after noon to inspire a new round of speculation. The army men refused to divulge their names to newsmen and kept distant from any persistent interviewers.

While speculation was highest, the army group slipped away from police headquarters with the saucer about the size of a bicycle wheel—and whisked it back to Salt Lake City. Shortly after their departure, McCracken announced the whole thing was a hoax.

In hindsight, the investigation and hoopla that went into the episode may seem like overkill, but at the time, the makeshift disc carried an aura of possibility: what if the emblem really was an otherworldly machine sent from the far reaches of space? The "little green men" inside, so to speak, would have been the find of the century. And to think it might have happened in little ole Twin Falls!

In reality, it was a prank. But alas—at least in hindsight—it was a funny one. I wonder if anyone at the time laughed about it. Maybe Mrs. Easterbrook, Mr. Thompson or the other neighbors shared a chuckle or two

after the dust had cleared. Maybe the police officers or even the FBI agent smirked when they returned to their offices. As a journalist myself, I can only imagine how that AP reporter must have smiled as he wrote his article. I wonder if the culprits, the young boys, if they, too, shared a laugh or two. The episode definitely is one for the history books, something that should be retold and not forgotten.

Chapter 18

Chipping Away at Balanced Rock

The rancher hoisted an ax, swearing to himself that the towering rock was more a menace than a historical icon, and swung the tool against the small base, each swing chipping away at the basalt that held the rock in place. He swung again, and again, and again—his sheep standing afar off, staring with animal disinterest—and the rock that looked like an upside-down boot still didn't fall.

In the desert of western Twin Falls County lies the small town of Castleford. The landscape is dotted with green farmyards and dry, golden-brown fields—the two colors complementing each other to the point of abstraction. Cattle roam the pasturelands and snakes the desert turf. And at one place on the upside of a moderate ravine stands stately Balanced Rock, an iconic emblem of the Magic Valley that draws visitors far and near every year.

The famous rock, which towers some two hundred feet above the canyon floor, is noticeable from the nearby roadway where a small parking area sits. Narrow trails crawl up the dirty mountain to the rock, where in summertime sunflowers grow amid the brown sage. The trail can be slippery because of loose dirt, especially on the descent, and so good hiking shoes are important. If you're healthy and in good shape, the hike shouldn't take more than five minutes, though the incline is rather steep.

At the top is the rock—a basalt monolith formed thousands of years ago by differential wind and weather patterns. It is forty-eight feet tall, forty feet wide and sits atop a base that is little more than three feet wide, according to a bullet-holed sign across the road from the site. Visitors who view the rock say they've seen it before. Some say it looks like a question mark or an upside-down boot; others claim it looks like the African continent. No matter what it might remind you of, however, what's most interesting about the rock is that it "balances" on a rock pedestal only a little more than three feet across at its widest point.

It has become one of few symbols of the Magic Valley, and pictures of the rock can be found in many area restaurants and other establishments. Some of the black-and-white images date from the late 1800s or early 1900s, as the rock as attracted visitors for a long time. Some have been unnerved by it, fearing the rock would topple over and cause harm to weary bystanders or even farm animals.

According to one local legend, as recorded in the *Times-News*, a sheepherder, fearing the rock would lose its balance and fall on his sheep that grazed in the vicinity, took an ax to the base and tried chopping it down. As a reporter I heard a similar story from Max Yingst, recreation planner for the Bureau of Land Management's Jarbidge Field Office.

"Someone had apparently wanted to see it roll down the hill," he told me in 2009.

Still doing its balancing act, however, the iconic forty-ton rock appears it would do much more than roll if it ever did fall: it could literally do some damage. The base was shored up to help prevent further vandalism. It's a good thing, because the area wouldn't be as memorable without it.

At the top, a view of off-road trails can be seen in the area's expansive open fields and rolling hills—a stark contrast to the monument's rocky terrain.

What do visitors say of the rock? One answer comes from a 2009 article I wrote about the site. It begins with an out-of-state visitor:

> *The man and his two children appeared insignificant standing below the 48-foot tall monolith, which looked as if it might topple over upon them.*
>
> *But just as it had for thousands of years, the rock held its place.*
>
> *"It's unbelievably massive," said visitor David Rivera. "But the base is so small."*

Rivera had come to the Magic Valley from Spokane, Wash., for a local conference, and while here he decided to visit Castleford's Balanced Rock.

When he stopped for directions at a local business, the woman helping him chuckled. She did not seem to think Balanced Rock was worth much of a visit, Rivera said. But he wasn't disappointed.

"I'd recommend it to anyone who has not seen it before," he said. "It was very impressive."

Visitors to the area also enjoy nearby Balanced Rock State Park, developed by the Castleford Men's Club and given to Twin Falls County in the 1960s. Here, you can see other interesting rock formations—though they wouldn't be as intriguing if not for their famous big brother—such as tall hoodoos and sheer rock walls where birds like to roost. Keep looking up and chances are you'll see birds of prey soaring against the backdrop of a blue sky that here appears like a canopy. It is indeed best to visit the park and its famous rock on a blue-sky day, because the rock formations stand darker against the blue canvas. As continued in the article:

Farther in the canyon, eye-catching rock formations—some covered in moss, others dotted with holes—fill parts of the landscape. A narrow trail runs along the river, and the hike is easy without many inclines. But you can only go a half-mile or so before travel is blocked by a rock wall.

The sounds here—such as the semis that roar their way along 3700 North near the park's entrance—seem distorted, almost haunting, as their vibrations bounce back and forth along the rocky walls.

Even shored up, one wonders if the iconic rock will forever hold its balancing act. It's already stood for thousands of years, and so the chances of it standing many more are likely. Let's hope so, because the formation has become a decorative monument in an otherwise nondescript landscape.

Chapter 19

Evel Knievel vs. the Snake River Canyon

You've heard the name—Evel Knievel, a contemporary daredevil who in 1974 attempted jumping rim to rim across the Snake River Canyon from Twin Falls to Jerome County. The episode is well known by locals and in history books, especially those titles with a local flair. So why is the story included in a book of forgotten tales, when in fact such an event is far from forgotten?

Because I believe that though the jump itself is well remembered, there are details about it—such as why the jump failed and how Knievel could have died if Mother Nature hadn't interfered—that are not well known.

If by chance you're one of those persons who already know the details, chalk up this chapter to the author's own experience: I was only a little boy living in Southern California when the jump occurred and vaguely remember hearing about it then, but only recently did I find out some of the details. I thought they

were interesting and wanted to share them with you, just in case you hadn't heard of them either…or in case you forgot.

Seven Years of Trial and Error

Some dreams take a while to come to pass. Some of them never do come to fruition but instead are left on the whims of fancy, a collection of what ifs.

What if I had successfully completed the jump? Or what if the rocket had landed in the water? What if I wasn't able to tear myself free?

These questions are likely ones that daredevil Evel Knievel asked himself after his now-famous attempt at jumping across the Snake River Canyon in the early 1970s. For the Butte, Montana–born thrill seeker, the goal of being the first person to complete such a task took several years of preparation and trial. While he ultimately failed at completing the jump—that is, landing on the opposite side of the canyon from whence he launched—he succeeded in giving it seven years of effort and iron-man nerve.

They were years of trial and error that dipped heavily into his pocketbook and left the thirty-five-year-old daredevil wondering what he was doing trying to make such an event happen. Several unmanned test launches were conducted, each of the machines being prototypes of the steam-powered X-2 Skycycle Knievel would eventually

use on the ill-fated 1974 jump. The small rocket-like cycles launched east of the Perrine Bridge in Twin Falls, jumping high above the canyon floor and aiming to propel some three-quarters of a mile across to the Jerome County side of the canyon rim—the same jump Knievel would make on the now historical jump day. Each of the test jumps failed, the rocket-cycles splashing into the green waters of the Snake.

By summer 1974, more tests would be important, but Knievel was running out of money. Either he'd attempt making the jump himself, no matter that the tests had failed, hoping to earn big money from ABC to broadcast the launch, or he'd forego the idea and move on to something else. The answer was inevitable: this was too big an opportunity to pass up, and already he had started promoting the jump. The money would be nice but so would making a cut in the history books.

THE MAN AND THE HOUR ARRIVE

Like a collision with destiny, the date was set—and the man and the hour arrived.

September 8, 1974: the crowds, reporters and emergency units gathered near the canyon rim in Twin Falls and Jerome, waiting to see the daredevil take his giant faith-bound leap into the sky and step across the three-quarter-mile-wide canyon—albeit done with a modern steam-powered machine called the Skycycle.

As the man of the hour sat strapped in the seat of his newfangled contraption, we can only imagine what thoughts ran through Knievel's head. Were they ones of self-confidence, determination and (some call it craziness) courage? Or were they of fear and misgiving? Likely there were both, anxiety and anticipation. The long-awaited jump was at hand.

The engine started, the crowds cheered, the broadcast reporters said their thing. The engine roared, and Knievel sent the Skycycle up the ramp some five hundred feet above the canyon floor, targeting his date with destiny. But then, from his cockpit, the view changed. No longer was he headed to the other side of the canyon but down on a slow descent to the canyon floor—to the very side he had launched the rocket.

"He's up, he's up," Kelly Klaas, a local radio personality, recalled saying at the time. "Now he's going down, he's going down!" It was pretty much the same thing that other reporters were saying.

What spectators saw was a parachute open and then the nose of the rocket dip toward the canyon floor.

In reality, what happened was "an electrical malfunction" that caused the parachute to deploy automatically shortly after takeoff, Knievel said later in a television interview. Then, all of a sudden, prevailing winds whisked the Skycycle back toward the Twin Falls side of the canyon, Knievel no doubt cursing his bad luck. Lucky for him, he landed on dry land instead of water. If Mother Nature—

err, the high hand of Providence—had not interfered, the outcome could have been disastrous.

"As the vehicle is going down, the wind is blowing me back into the canyon wall," Knievel said in a later interview about

the episode. "I'm fighting, trying to get out of it. People didn't realize it, but I was trying to cut myself free; I was tied in that thing. If that would have gone in the river I would have absolutely drowned. I was a dead man…how I ever made it, how I ever lived is just a miracle."

Though the daredevil didn't make it across the canyon, the event was a party nonetheless, both locally and nationally, as thousands turned out to watch the attempt while millions of others across the country tuned into the event on their television sets, fingers crossed for a successful and safe jump.

Many locals still remember the event, though not all of them knew the details of the malfunction.

Klaas, who was working for KEEP Radio at the time—he later hosted *Top Story* for many years on 1310 KLIX and retired from the station after more than forty years in radio in December 2014—watched the jump from inside a small house that acted as the station's temporary studio not far from the launch site. He remembers crowds lining both sides of the canyon rim and the Perrine Bridge.

Klaas said it wasn't common knowledge at the time what exactly happened that caused the parachute to deploy early, but he said there've been rumors even to this day that Knievel flipped the switch willingly. The more likely thing that happened is exactly what the daredevil said happened: an electrical malfunction.

"That seems the most plausible to me," Klaas said, noting that the event at the time was considered by local media as a local event, not so much a national spectacle.

ABC had threatened the radio station at the time, saying it had full rights to the story and if KEEP broadcast the event the national network would sue. "We did anyway, and they didn't," Klaas said with a chuckle. It was a fun, memorable time that he was happy to be part of in his own small way, reporting a bit of history to the local audience.

The jump failed in that Knievel never made it across the canyon, but it did a couple of other things: it helped put Twin Falls on the map, bringing national attention to the area; and it made it into the history books. The event is still fondly talked about today—even in the vein that other daredevils have or are, as of this writing, seeking their own chance to jump the Snake River Canyon.

Monuments of Men

Knievel's ill-fated 1974 jump is still impacting people today, including in the city of Twin Falls, which over the past several years has received several pitches by would-be daredevils about attempting their own jumps across the three-quarter-mile-wide canyon. As of this writing, no one else has attempted the leap, though the one coming closest to actually striking a deal with the city to do so was Eddie Braun, who had planned a jump on September 8, 2014, the fortieth anniversary of Knievel's jump. The event didn't come to fruition, though, and was tentatively postponed for the following year.

Many stunts Knievel pioneered during the 1970s have been repeated and bested by other daredevils. But the Snake River Canyon looms unconquered and will, perhaps, forever attract dreamers and schemers to the dirt mound that remains. "In that way, Knievel, his legacy and his fans are forever linked with the Magic Valley city perched on the canyon's rim," reads an AP report from September 10, 2014.

> *Seven daredevils lined up hoping to jump the canyon for the stunt's 40th anniversary on Monday* [September 8, 2014]. *Only one team still appears viable. While they have not scheduled a launch, they have rockets and a ramp at the ready and say it is only a matter of time. On that team is Scott Truax, son of the engineer who built Knievel's X-2 Skycycle. Truax and would-be jumper and Hollywood stuntman Eddie Braun call their project a tribute to Knievel.*
>
> *Their aim? To "cure history." Whether that can be achieved or is just a marketing line depends on whom you ask.*
>
> *"A successful, well-organized jump would go a long way in curing some of those wounds," said Mayor Don Hall, who watched the jump on television from Utah as a teen.*

As for Knievel and his daring escapade, the daredevil died in 2007, while his memory lives on locally and among thrill seekers across the globe. "It was a less-than-auspicious

milestone for Evel and the city of Twin Falls," reads an entry on RoadsideAmerica.com, "but Evel's fans loved him for at least trying." Something that helps keep the legend alive is the launch pad he used in 1974. It still stands east of the Perrine Bridge, in easy view from the Twin Falls Visitor Center along the canyon rim. A marker at the center reads:

ROBERT "EVEL" KNIEVEL
EXPLORER, MOTORCYCLIST AND DAREDEVIL
ATTEMTPED A
MILE-LONG JUMP
OF THE SNAKE RIVER CANYON
ON SEPTEMBER 8, 1974
EMPLOYING A UNIQUE
SKYCYCLE
THE LARGE DIRT RAMP IS
VISIBLE APPROX. 2 MILES
EAST OF THIS POINT
ON THE SOUTH RIDGE
OF THE CANYON.
DONATED
TO THE COMMUNITY
BY SUNSET MEMORIAL

Part V

CONTENTION AND CAMPS

Chapter 20

Idaho's *Almost* Forgotten War

For some people, it might take a lot of nerve to stand up for what they believe in, but not for Amy Trice, who in 1974 stood tall and proud against the United States of America. Her stance, coupled with the efforts of sixty-seven other people from the Kootenai Nation, has gone down in history as Idaho's little-known war.

No armaments had gathered, no swords were drawn or guns aimed, no cannons were fired, but the conflict nonetheless was heated. Lines were drawn in the proverbial sand, with each side taking a stance—Trice, a resilient woman, accusing the government of negligence against her people and the government acting as if it had done nothing wrong.

The Kootenai had lived in the northwestern parts of the country for centuries, flourishing among the vast wilderness of the Pacific Northwest and into what later would be called Idaho. They were as much a part of the land as were the deer and beaver.

And then the white man came, which to the Kootenai must have seemed like prowlers in the night, seeking to rummage and take what they believed was theirs but that the Indians had known for much longer.

The white man, despite his good intentions for favor and success, is a cocky breed who, in hindsight, has left a permanent stain on some instances of our nation's history. Such is the case when it came to the Native Americans, of which the Kootenai are a part.

Over the years, lands were taken from the Kootenai, as were their hunting rights, and the people moved from one place to another within Bonners Ferry, their native cultural heritage all but gone. Whereas they used to be rich thriving off the land, a diversified people remaining true to their cultural roots, now they felt scalped of their heritage, so far removed from their previous life, and in their new home they experienced extreme poverty.

The U.S. government—which in the past, sadly to say, seemed to have little respect for our native brothers and sisters—offered the Kootenai people homes, but these decrepit-looking houses were barely habitable with their broken windows and shabby roofs. They weren't good enough for a government official, most likely a white man, and yet the houses were given to the Kootenai. Heck, the Indians had lived off the land for centuries, they might enjoy the open-air structures.

Right?

Wrong.

What the episode shows is the country's disregard for a people it should have embraced and treated kindly instead of one it gave little attention to. "More than a million acres were signed away without the Kootenais' presence under the treaty of Hellgate, Mont., in 1855," reads a *Landmark News* article by Tim Woodward. "In 1962, the government gave the tribe 36 cents an acre, based on 1855 land values."

And then the inevitable happened. A tribal leader named Moses Joseph died from exposure while in his unheated home during a cold night. The people began to fear, wondering who would be next. Their population was dwindling, and they were cut off from government aid. Would all of the Kootenai be wiped out because of the shabby homes they had been given? It wasn't right; something must be done! "From the tribe's perspective," reads Woodward's article, "the war wasn't merely a protest. It was a fight for survival."

Enter Amy Trice, who worried that if something wasn't done, her whole people might face annihilation, not by the emblems of wartime battle, but by freezing to death in shoddy homes given them by the federal government. The straw had been broken; Trice and her people had had enough.

"It all started when Simon Francis talked to my father, and asked him if his daughter, me, would be on the council," Trice told the *Bonner County Bee* in an August 6, 2010 article.

> *"Dad told him it was up to me, and later on he asked me if I'd run."*

She agreed and was elected, but all her efforts to find justice and help for the tribe, which had never signed a treaty with the United States, fell on deaf ears, as the tribe, she was told, was "too small."

She went up the hierarchy in the Bureau of Indian Affairs, and gained nothing. She and a delegation traveled to Washington, D.C., to meet with Idaho's congressional delegation, which included Sen. James McClure and Rep. Steve Symms, who listened, but offered no help.

"So I came back and said, 'Let's start a war,' as a joke, but then it got serious," she said.

Concerned about public reaction, she encouraged the tribe's elders and others who feared repercussions to leave, but only a handful took the opportunity, with the vast majority of the tribe standing together. Indians from other tribes came to lend their support, noted Indian activist Dennis Means offered to come, but Trice insisted on no guns, no drugs.

"It was a war of understanding, a call for attention to how the people of the tribe were living," Amy said.

In essence, Trice's efforts brought awareness to the plight of her people and helped them reclaim their land and livelihood. A one-hour film by Sonya Rosario, released in 2010, tells the plight of the Kootenai people. It is a documentary that needed to be filmed and should be watched frequently.

Trice passed away at the age of seventy-five on July 21, 2011, having done more for her people than she ever imagined possible.

"I'm really looking forward to it," she told the *Bonner County Bee* of the film.

> *"As a little girl, I never thought I'd grow up to do something so big."*
>
> *Beset by tuberculosis as a child, and having gone through more than two years of blindness, she often wondered if she'd grow up at all, she said.*
>
> *"I guess God had a purpose for me."*

Chapter 21

RELOCATION CAMPS

In this age of digital advancement and technology, just when you might think that everything that can be discovered has been brought to light, another revelation is offered that further sheds light on our interesting, though sometimes shameful, past. Case in point is the Kooskia Internment Camp, discovered in 2013 in the mountains of northern Idaho.

"There are no buildings, signs or markers to indicate what happened at the site 70 years ago," reads a July 27, 2013 Associated Press article by Nicholas K. Geranios, "but researchers sifting through the dirt have found broken porcelain, old medicine bottles and lost artwork identifying the location of the first internment camp where the U.S. government used people of Japanese ancestry as a workforce during World War II."

We've heard of the concentration camps of Hitler's regime, but not as well known are the camps the United

States built to house Japanese immigrants during the volatile and unsure times of the 1940s. The political leaders of the day, fearing that our Asian American brethren could somehow be a threat to the United States, made a concerted effort to lock them away in internment camps, specially built facilities in out-of-the-way places in many parts of the country.

Why the country's leaders felt such camps were necessitated is understandable, to a point. The United States naval fleet was attacked by Japanese aircraft on December 7, 1941, at Pearl Harbor. More than 2,400 naval officers and civilians, including women and children, were killed on that ill-forgotten day that prompted the United States to enter into World War II and its eventual decision to drop atomic bombs on Hiroshima and Nagasaki. It was at Pearl Harbor that Japan sealed its fate, and in a way, those with ancestral or cultural ties to that country became the enemy.

"In February 1942, President Franklin D. Roosevelt signed an executive order that moved nearly 120,000 Japanese and Japanese-Americans into ten isolated relocation centers in Arizona, Arkansas, California, Colorado, Idaho, Utah, and Wyoming," according to the National Park Service website. "These temporary, tar paper–covered barracks, the guard towers, and most of the barbed-wire fences are gone now, but the people who spent years of their lives in the centers will never forget them."

Individuals and whole Japanese families—many of whom were born and raised in the United States—were

hidden away from civilization and, by the very nature of the lockdown, were treated as less than human. These camps, of course, were not the hideous things the Nazis built. As far as we know, for instance, there were no means of deliberate experiment, torture or death at the U.S. camps; but as Geranios writes, they were nonetheless "a shameful chapter of American history."

The Kooskia Internment Camp was not unlike similar camps across the country, including the Minidoka Internment Camp in south-central Idaho. The camp—the great wall of southern Idaho—had "five miles of barbed wire fencing and eight watch towers surround[ing] the administrative and residential portions of the relocation center, which was located on 950 acres in the west-central portion of the reserve" north of Twin Falls and east of Jerome County, according to the online "Confinement and Ethnicity: An Overview of World War II Japanese American Relocation Sites" by J. Burton, M. Farrell, F. Lord and R. Lord.

This internment camp was open from August 10, 1942, to October 28, 1945, housing an estimated 7,318 individuals who'd been ordered here from Alaska, Oregon and Washington. In the first two days, 200 internees arrived. In all, more than six hundred buildings were located here, including staff and residential housing, a civic center, a high school, a military police compound and a hospital.

However, "many local residents knew little about the tiny Kooskia camp, which operated from 1943 to the end of the war and held more than 250 detainees about 30 miles east of its namesake small town, and about 150 miles southeast of Spokane, Wash.," according to the AP article. Secrets of the camp are only beginning to come to light:

> *The camp was the first place where the government used detainees as a labor crew, putting them into service doing road work on U.S. Highway 12, through the area's rugged mountains.*
>
> *"They built that highway," Camp said of the road that links Lewiston, Idaho, and Missoula, Mont.*
>
> *Men from other camps volunteered to come to Kooskia because they wanted to stay busy and make a little money by working on the highway, Camp said. As a result, the population was all male, and mostly made up of more recent immigrants from Japan who were not U.S. citizens, she said.*

The all-male camp population was made of recent immigrants from Japan, as well as those of Japanese ancestry from Latin American countries, and they received between fifty and sixty dollars a month for their work.

The University of Idaho researchers studying the camp are eager to make sure it is not again forgotten to history. "We want people to know what happened, and make sure we don't repeat the past," anthropology professor Stacey

Camp, quoted previously and who is leading the research, told the Associated Press. The camp was one of several operated by the Naturalization Service, but

> it was so small and so remote that it never achieved the notoriety of the massive camps that held about 10,000 people each. After the war the camp was dismantled and largely forgotten. Using money from a series of grants, Camp in 2010 started the first archaeological work at the site. Some artifacts, such as broken china and buttons, were scattered on top of the ground, she said.
>
> "To find stuff on the surface that has not been looted is rare," she said.
>
> Camp figures her work at the site could last another decade. Her team wants to create an accurate picture of the life of a detainee. She also wants to put signs up to show people where the internment camp was located.
>
> Artifacts found so far include Japanese porcelain trinkets, dental tools and gambling pieces, she said. They have also found works of art created by internees.

Part VI

WACKY AND WEIRD

Chapter 22

Snaring the Bear Lake Monster

Southern Idaho is the partial home to a beautiful, emerald lake it shares with Utah—and, allegedly, a water serpent that over the years has been reportedly seen by many witnesses. Stories about the Bear Lake Monster started long ago after the Cache Valley region was settled by Mormon pioneers in the 1860s.

Actually, the Mormons were just reciting what they had heard from the Indians, who claimed a large serpent would rise out of the water and snatch young maidens and braves at the shoreline.

A creative writer by the name of Joseph C. Rich heard the Indian legend and wrote a story called "Monsters in Bear Lake" for the July 31, 1868 edition of the Mormon-owned *Deseret News* in Salt Lake City. That got people thinking—and talking—and before long others started claiming they, too, had witnessed the Bear Lake Monster.

A man named C.M. Johnson, according to the book *Folklore in the Bear Lake Valley*, claimed he saw the head and long neck of a creature rise from the water's surface. Even Brigham Young seemed to have believed the stories, for he supposedly offered rope to a hunting expedition to snare the monster.

Apparently, there was more than one such creature.

In 1871, the *Salt Lake City Herald* reported that a man had captured a young member of the monster family near Fish Haven. "This latter-day wonder is said to be about twenty feet in length, with a mouth sufficiently large to swallow a man without any difficulty, and is propelled through the water by the action of its tail and legs."

Over the years, varying descriptions of the monster have circulated. Some stories said the creature resembled a walrus, large carp or dragon, while others said it looked very much like a crocodile or duck-billed creature. No one seemed to agree on its length, having it anywhere from twenty feet to ninety feet long, and reports were made that it was able to swim up to sixty miles per hour.

The varying descriptions could have a couple of explanations: either there were different-sized creatures in the lake, all part of the same monster family, or the tales were all tall. Apparently, some twenty years after he wrote his article, Rich confessed that he had made up the story to draw attention to the area—which makes the topic even more interesting because his confession did little to stop other stories from being told by alleged witnesses who

claimed they really did see a serpent monster in the lake. Such stories are once in a while even told today.

Are they fact or fiction? The answer, in this case, depends on what your level of belief is in the unknown.

Chapter 23

A Strange Occurrence at INL

Since 1949, the Idaho National Laboratory in Idaho Falls has been a science-based applied-engineering laboratory that, according to the facility's website, supports the U.S. Department of Energy's missions in nuclear and energy research, science and national defense. Work done here is important, protected and, if you believe in that kind of thing, could be of interest to other species. Over the years there have been many reports of unexplained flying objects seen in the area, and one of the more strange tales was reported in mid-July 2010 while a wildfire raged near the facility.

In the midst of heavy smoke, a shiny disc-like object appeared in the skies while bystanders stood by and watched the object, whatever it might have been, fly in and out of the smoke. The object was caught on film twice by KPVI News 6. Some viewers, after watching the video when it was posted online, claimed it might have been a bird or

helicopter. Others refuted those ideas, saying it neither looked nor acted like a helicopter and a bird wouldn't fly into smoke like this flying object did. Usually animals flee from flames, not go toward them. The discussion the video drew was, if nothing else, entertaining to read. Commentators were befuddled at what they had viewed and their stories quirky as they made up scenarios that to them made sense.

"I know you probably won't be happy with me saying it's a bird," one person wrote on the Above Top Secret website, "But…I've now watched that video at least ten times…I can even see the wings extending down and flapping on a couple of occasions. If you look at it carefully, you'll be able to see that too."

Another post read, "But then again, why would a bird be flying around in smoke? So many questions, so few experts." One blog writer even went so far as to say, "Animals are generally smart enough to not hang around in toxic fumes. Do you think it could have been an alien that shape-shifted into a bird?"

Still another post:

> *I accept there are skeptics and fence sitters and this is okay when dealing with this subject. But, you should be able to also accept the fact that there are millions of* [people's experiences] *with Alien's and AFO's* [alien flying objects] *and they know what they know just like the skeptics and fence sitters feel they know what they know. I KNOW there are Beings*

which we call Alien's [that] exist and they do travel via AFO's....Now I don't know if these videos and still pictures are Alien or a bird as suggested. I believe we need a true professional that deals with this to investigate and give his/her knowledge on this, that's all...plain and simple. Maybe we will all be proven wrong and it is a pink elephant.

No expert, if there is such a thing when it comes to UFOs, has ever stepped forward to confirm the identity of the flying object, thus allowing rumor and speculation to continue. As for me, I tried accessing the video footage myself, but I was too late; the recording had been removed.

Chapter 24

The Mysterious Creature of Rose Hill Cemetery

One of the more bizarre tales to come out of Idaho Falls is the story of the Rose Hill Cemetery werewolf. The tale dates back to the earliest history of Idaho Falls, when a number of grisly murders occurred. They were so brutal, in fact, that it was determined a wild animal had done the killings, not a person.

Rumors started, the one most prevalent being that neither person nor animal had done the killings, but something more sinister—a half-man, half-beast creature that stalked the starry night.

Police couldn't stop such a creature, however; it would take a town effort. And that, apparently, is what was done. The townspeople got together and hunted the beast, pursuing it through streets and rural landscapes until they finally caught up with it. And then, *BANG*! The beast fell and the townsfolk moved in to see what it was they had killed. It indeed appeared to be very much like the traditional

werewolf. Would it stay dead, they wondered? To make sure, they cut the beast in half and buried its body parts in two separate graves to prevent any supernatural activity from unearthing the devil beast. It couldn't come back to life if it were split in two, buried six feet under the earth in two burial spots, could it? They then placed a headstone on each burial spot. One read "Were," the other "Wolf."

As the legend goes, the residents' efforts were in vain, for not even the separation of two graves could keep the werewolf from resurrecting. Not long after they had buried the creature, they found the graves open and a large bite taken out of the headstone that read "Wolf."

There have been no further sightings of the werewolf since that terrible day, and luckily, there've been no more gruesome murders in the vicinity attributed to the beast.

Chapter 25

A Little of Egypt in Boise

There's a little bit of Egypt in Idaho in the form of the classy Boise Egyptian Theatre, which also, according to local legend, has a touch of the paranormal. A little about its history might explain why.

As reported in *Haunted Idaho*, the facility was built in 1927, during the age of the silent film, but it didn't keep its name for long. The following decade it was known as the Fox Theatre and in the 1940s as the ADA before retaking its former name in the 1970s. When it was constructed, great care was given to detail. In an effort to use Egyptian architecture, the building was modeled after the then newly discovered King Tut's tomb. It changed looks over the years, as it did its names, finally returning to its original design in 1999. Today it is one of few theaters from the grand cinema and movie palace era.

The theater, which sits on the corner of Capitol Boulevard and Main Street, is rented to private parties

and is used for any number of events including concerts, opera performances, film festivals, conferences and even weddings. The building is one of the city's most loved buildings and is known in paranormal circles as one of Boise's most haunted.

"It's not been a bad experience, it's just been an alarming one," the house manager told KTRV FOX 12 in Nampa in a July 2009 report about the building. He was referring to an experience he had while in the facility. He claims to have seen an apparition in its projector room and felt something touch him. "I don't know if there's words to explain it, really, it's just that you try not to think that there was nothing there that you've actually seen, or that something's actually touched you. Apparently there's something."

The shade in the projector room is something others apparently have seen, for it's been rumored for a while that a male figure haunts the small space. It's believed the ghost belongs to a former projectionist who worked here in the 1930s and possibly died of a heart attack while working one day.

Paranormal investigators who've investigated the building also have witnessed the apparition and have caught voices on their digital recorders. They say it's not a threatening place, but one that definitely has its share of strange phenomena.

Perhaps there's a simple answer as to why ghosts may haunt the facility: they like movies.

Chapter 26

Miniature Soldiers and a Ghost

The spirits of children and at least one woman allegedly haunt Fort Boise Military Cemetery, where the grave markers honor deceased veterans. Interestingly, no reports of the soldiers interred here have been recorded.

A story in *Haunted Idaho* discusses this cemetery, which originally was located about a half mile south of its present location, near the Boise Barracks, according to the City of Boise website. But after a flash flood "roared down Cottonwood Creek," 166 graves were relocated in 1906 to their present site. The graves were a mix of enlisted servicemen, family members and civilians. "A short time later," reads the website, "additional graves were discovered at the original site by soldiers using the old cemetery as a target range. Military activity was halted until these graves were disinterred and moved to the new cemetery location. Additional burials took place—along with disinterments—through the spring of 1913 when the Boise Barracks were closed."

After World War II, because of funding issues, the Department of Veterans Affairs decided to close a number of its smaller cemeteries. At the request of the U.S. Army, however, Fort Boise Military Cemetery was left undisturbed, and in 1947, it was deeded to the City of Boise with the understanding that the cemetery would be maintained as a historic site. It was to remain much how it looked in the early 1900s. Three more people, their identities now lost to history, were given soldiers' burials at the cemetery on Memorial Day 1998. It is believed they were Civil War veterans, unearthed during flood control excavation in the vicinity of the original cemetery.

Over the years, insensitive and careless visitors have vandalized parts of the isolated cemetery, according to the city's website:

> *Graves were sometimes used as targets, markers were stolen, fencing and gates painted, and the flag pole was disabled. In 1978, the 420-acre parcel surrounding the cemetery was named a reserve by the Park Board of Commissioners in an attempt to retain the ecological, natural state of the area. Subsequently, trails were developed, road access improved and more people enjoyed the recreation opportunities in the preserve. Increased use greatly reduced vandalism.*

It's obvious today that the cemetery has been in good hands, for a number of flowers and other plants have been

planted in the area, though not all of them have lasted because of the poor soil. But weeds are trimmed, walkways are cleared and markers have been righted and repaired.

"Some visitors may get the sense that the cemetery has been abandoned, a solitary resting place of the forgotten," reads the website. The goal of the Boise Parks and Recreation Department, which maintains the graveyard, "is to retain the integrity of the site, respect the land, prevent alienation to the cemetery and most of all, honor the memory of those who rest there."

But not everybody who was buried here seems to rest. The images of ephemeral children walking around the graveyard at night have been reported, and some say they've seen the shade of a woman both at the cemetery and nearby elementary school. Ironically, I didn't hear any reports about soldiers' spirits haunting the grounds. But the cemetery, located at 750 Mountain Cove Road, sits near a school. The ghost woman has reportedly been seen there as well. Perhaps in mortal life she worked as one of the school's teachers, but why her spirit doesn't rest can only be surmised. The question more on my mind is why soldiers' spirits don't seem to make their presence known at the old burial grounds.

THE STRANGE HISTORY OF IDAHO GHOST TOWNS

No matter where they might be found, ghost towns are interesting places to visit—and Idaho has its fair share of such locales, towns that once bustled with people and business but later succumbed to failed economy, disaster or community ruin. Here are a few ghost towns and their brief, interesting stories. Oh, and some of them may live up to their reputation; apparently, as I reported in my book *Haunted Idaho: Ghosts and Strange Phenomena of the Gem State*, ghosts are rumored to make their appearance in them now and then.

HOW PIERCE CAME TO BE

A number of spirits are rumored to haunt several establishments in the small town of Pierce, Idaho, in Clearwater County in the central-east portion of the

state's panhandle. Pierce is perhaps best known as a former mining town whose roots began in 1860, the year of the area's gold rush.

The town, which at the time was part of Washington Territory, was named after Elias Davidson Pierce, a prospector and key player in the gold rush. Pierce had immigrated to the United States from Ireland, first settling in South Carolina before moving to Indiana and eventually to California. It was gold fever of 1849 that drew him to the Golden State, though finding his wealth wasn't his only ambition. In 1852, Pierce managed to secure a seat in the California House of Representatives before heading to Washington Territory to seek further riches.

Once here, Pierce and friend Wilbur F. Bassett, of Orofino Creek, made the discovery of gold in the area in 1860, initiating the rush. Prospectors swarmed to the area, hoping to glean at least a little of the wealth promised from finding the precious ore. Buildings began to be constructed, including a courthouse in 1862 that today is hailed as Idaho's oldest public building. A year later, Idaho Territory was established, and in 1884 the county seat, which formerly was Pierce, moved north to Murray in Silver Valley. It moved again to Wallace in 1898. Present-day Clearwater County, named after the nearly seventy-five-mile-long Clearwater River in northern Idaho, was created in 1911. The river has its own history, for in 1805 Meriwether Lewis and William Clark, on the now historic Corps of Discovery Expedition, descended the river in dugout canoes. The two-year journey,

from 1804 to 1806 and commissioned by President Thomas Jefferson, was the country's first transcontinental expedition to the Pacific Coast.

According to census records, Pierce had a population of 508 people in 2010, while the county itself was home to 8,761 people. As for the ghosts, it's not unheard of to sense a quiet foreboding in the area where miners' spirits are rumored to still linger. You can tell they are here by the unnerving feelings of being watched or followed. Slight breezes on the skin, as if some unseen entity just passed by, have been felt by some visitors, while others have reported seeing shadow figures in the area. These are common reports in old mining and ghost towns. Sometimes phantom scents, such as the rancid smells of sweat or tobacco smoke, also have been reported in the area.

Disaster at Colburn

The small unincorporated community of Colburn, located in Bonner County in Idaho's panhandle, like many of America's historic town sites, once was much busier than it is today. In 1905, the *North Idaho News* described it as a "busy village." It became popular because of the lumber and railroad industries that eventually came to the area—not surprisingly, since northern Idaho is one of the state's most scenic and tree-filled regions. Nearby Sandpoint, for instance, is known as a "tree city" because of its diversity of tree species.

Colburn, located about nine miles north of Sandpoint, was named after Jean Baptiste d'Armour de Courberon—or "Big John Colburn"—who was employed by the Great Northern Railroad. In 1920, businessman Harry E. Brown purchased the mill and, according to a short history about the area by Bob Gunter on the Sandpoint County website, by 1928 had it in full operation, employing around sixty workers; Colburn itself grew to more than three hundred residents.

But like many towns of the emerging West, it eventually was plagued by disaster and loss. "One disaster after another struck the little town until today there is not much left that indicates where it stood," Gunter writes. The railroad closed in 1935, followed by several fires that destroyed many of the buildings, including its schoolhouse that twice was struck by flames.

The memory of Colburn is disheartening, like failed dreams. Among the few buildings that remain, there also reside at least a couple of ghosts—though probably more—one of whom just might belong to old Mr. Colburn himself.

As the legend goes, on certain summer nights the apparition of a man can be seen walking the railroad tracks, and in his hand he holds a lantern high. What is the phantom doing? It's difficult to tell, because he never seems to stay around long enough for anyone to find out. If it's not Colburn's spirit that is walking the tracks, perhaps it is a former railroad guard, checking to make sure things in the old town are well.

The spirit of a woman also has been seen at the town's cemetery. Reports of the wispy woman figure have circulated since the 1920s, according to local stories. To whom does this spirit belong? Like the railroad ghost, we just don't know.

Hardship at Wallace

It happened all over the West: a thriving town full of prospect and promise suddenly collapses economically and forces its people to leave. The houses, businesses, churches and schools that once were occupied by its active citizens are left behind to remain empty vessels, historic tributes of a bygone day. The once-thriving towns now are ghost towns, and for many of them the moniker fits like a glove, for some of these ghost towns, empty of the people who once lived in them, actually are occupied by spirits of the dead.

A number of such towns exist in the Gem State; several are in northern Idaho, and one of them is the historic town of Wallace, though it is not quite the ghost town you might think it is. Living people still reside here amid the spirits.

Wallace, located in Idaho's Silver Valley, is not that different than other historic towns where mining once was an important means of preservation. Why isn't it different? The answer is an easy one: like similar historic sites, mining disaster eventually came to town.

Before disaster struck, it was Colonel W.R. Wallace, a Wisconsin lumberman for whom the town is named, who built the first log cabin here in 1884 along the South Fork of the Coeur d'Alene River. It didn't take long before the town became a popular mining community. Prospectors came by the dozens to look for gold, silver, copper, lead and zinc. By 1887, mining claims dotted the hillsides. But just three years later, in 1890, a violent labor strike broke out, and martial law was put into effect. That same year, the town was ravaged by a fire, as it was again in 1910. In 1913, the floods began.

"Flood conditions have grown so bad all over the Coeur d'Alenes following the heavy rains of the past few days that everywhere men are working not only to save their property, but to preserve their lives as well," reads a May 30, 1913 news article in the *Weekly Press Times*.

> *All yesterday the floods showed no sign of abating, and not until late last night, when it grew cold was there any appreciable let up in the size of the overflow. With a continuation of the colder weather through today, it is hoped that any further trouble can be anticipated and prepared for so that there will be little danger to either life or property as has been the case in the last few days. The high water came without any warning whatever, and in nearly every case, no preparations for it had been made. In all parts of the district, old timers say the water is the highest they have ever seen or heard of for this country.*

The greatest damage, the paper reported, was to the neighborhoods of Green Hill–Cleveland and Stewart Mills above the city, where two bridges were threatened, and a Pacific Railroad car, Engine No. 79, was "marooned in the car yards near the Mill."

Once the mills were reopened the next day, crews retrieved only "limited quantities" of ore.

Things weren't much better in nearby Burke.

"The torrent which rushed down Gorge Gulch carried away the ore dumps of the Moonlight and other mines in the gulch," the newspaper reported on May 28, 1913.

> *All this muck was deposited near the Tiger Hotel which is built across the river. As a result, the water was backed up for a few minutes when it flooded the hotel and began flowing down the main street of Burke. Before long, the whole of the current had made a bed of the street and a stream of water three feet deep and running at the rate of 25 miles per hour rushed through the town. Every house and building on the canyon bottom was flooded and the occupants were forced to take to the hills for protection.*

Nothing less than sheer determination of its residents kept the town's mining operations in force. By World War II, about forty mines dotted the valley. Eventually, like other such towns in the American West, Wallace slowly dwindled. Unlike some towns, however, it never quite died.

Instead of being a ghost town, Wallace today is a historic community that is home to around one thousand people. All of the buildings are listed on the National Register of Historic Places. It is a pleasant place to visit, if you like history and the outdoors, for here amid the rustic beauty of northern Idaho, there is much to learn about the area's colorful past and plenty to do in the way of recreation. There's also a ghost story or two here, including one about a spirit that likes to throw rocks at miners' hats.

A number of visitors over the years claimed to have seen figures dressed in period clothing peering at them from windows in the historic buildings and then quickly vanishing. Other stories have to do with the area's mines, where it is said that strange flashes of light and high-pitched screaming have been reported. As for rocks being thrown at miners' hard hats by unseen hands, well, that, according to the stories, has happened on more than one occasion.

If you visit the historic town of Wallace today, you won't be disappointed with the history you'll learn. But do keep an eye on those windows, as you just might see an apparition staring back at you. That, of course, would be icing on the cake—to see a period ghost in a town that very much resembles the past.

Part VII

PERSONALITIES AND PROFILES

Chapter 28

Rich, Famous and Historical Figures of the Gem State

Not everyone from Idaho is a potato farmer. Many are famous actors, authors, politicians, religious leaders and historical figures. You probably know about a few of them, but how many on this list did you know had ties to the Gem State? This is by no means a full and complete list, but each of the names mentioned here, with their talent and fame, adds to the colorful and historic flavor that is Idaho.

Adam West, born William West Anderson, best known for playing DC Comics' crime-fighting dark knight Batman on the 1960s ABC television show and theatrical release, had ties to the Gem State. He was originally from Walla Walla, Washington.

"While Batman, and his alter ego, Bruce Wayne, remains his signature role, Adam has a multitude of motion picture, theater, and TV credits to his name," reads an entry on his website, AdamWest.com. "Adam West is the author of two

books, *Back to the Batcave* and *Climbing the Walls*. He lends his support to numerous charities and won $250,000 on *Who Wants to Be a Millionaire*, on behalf of an organization supporting underprivileged women and children in Idaho. Adam splits his time between homes in Palm Springs, California, and Ketchum, Idaho."

Edgar Rice Burroughs, best known as the creator of *Tarzan of the Apes*, also published several other notable works, including *The Land That Time Forgot* and the Mars adventurer John Carter series. His tie to Idaho includes about six months living on his brother's ranch in Raft River in 1891. There were no jungle forests in southern Idaho to spark ideas for his ape-man adventures, but perhaps the more generally flat terrain and desert climate enthused him with ideas about lost lands and civilizations.

Burroughs was an active young man, participating in many activities to further his education and life experience. Though he spent much of his time outside of Idaho, he did purchase a stationery store in 1898 in Pocatello. It was short-lived, however, because the following year he sold the shop and, according to one website, spent the following winter "wrangling on the Snake River, Idaho."

Burroughs, after several months of health problems and a lifelong pursuit of literary adventures in several parts of the country, including Hawaii and Illinois, died of a heart attack on March 19, 1950, in Encino, California.

Ernest Hemingway, author of many classic novels, including *For Whom the Bell Tolls*, *A Farewell to Arms* and *The Old Man and the Sea*, is perhaps Idaho's best-known celebrity. Though the famous writer had traveled the world and lived in many places at one time or another, he chose to spend the last few years of his life—and the place of his death—in Idaho.

Hemingway's home in scenic Ketchum is today preserved by the Nature Conservancy. It is the place where, on the morning of July 2, 1961, the famous writer placed a double-barrel shotgun to his forehead and pulled the trigger. As disturbing and tragic as the episode is to remember, we should instead revel in the literature he left behind—stories that continue to pass the test of time.

Hemingway was in many ways the quintessential American writer, whose prose was crisp and simple and whose narrative style was all his own. Aspiring writers would do well to become familiar with Hemingway's form and approach to storytelling.

As for the man Hemingway, he was a charismatic and often eccentric fellow who loved the outdoors. Ketchum, with its rough beauty and quick rivers, was the perfect place for the writer to cast his fishing lines or venture into the wilds to waterfowl hunt.

The house was built and furnished in the 1950s by Bob Topping. When Hemingway purchased the house, it was the beginning of the end for the famous writer, who suffered depression once he felt he could no longer write; or

perhaps the depression, a vicious circle of ups and downs, caused his writer's block.

No matter now. The past is done, the tale not quite forgotten, his stories always remembered.

Ezra Taft Benson, thirteenth president of the Church of Jesus Christ of Latter-day Saints (1986–94) and acclaimed by millions of people the world over as a modern prophet of God, was born in the small town of Whitney near the Idaho-Utah border. In the 1940s, Benson, with ties to the farming life, served for eight years as the secretary of agriculture under the administration of Dwight D. Eisenhower.

As president of the LDS church, Benson challenged members to "flood the earth with the Book of Mormon" and, among other teachings, counseled church members against the pitfalls of pride. He was a stalwart patriot who deeply loved his country and espoused the constitutional freedoms it enjoys as God-given. He believed the Book of Mormon, an ancient record translated by Joseph Smith that gives an account of the former inhabitants of the Americas, warns modernists that shirking their duty to God will lead to calamity as it did to the country's former inhabitants and that, if heeded, the book can be a source of lasting peace and guidance to the soul and help better prepare its readers for the Second Coming of Jesus Christ.

Benson was born on August 4, 1899, in Whitney, Idaho, a place that forever remained in his heart and where early life

experiences taught him the value and blessing of familial relations, faith and church service and hard work.

"Like most farm boys, I grew up believing that the willingness and ability to work is the basic ingredient of successful farming," he said. "Hard, intelligent work is the key. Use it, and your chances for success are good. As an adult, this principle deepened into one of the mainsprings of my life."

Members of the LDS faith, familiar with the following names in church history, may find this interesting: "When Ezra Taft Benson was born…Harold B. Lee was only a few months old and Spencer W. Kimball was four years old," reads an entry on LDS.org, the website of the Church of Jesus Christ of Latter-day Saints. "Lorenzo Snow was President of the Church. The Salt Lake Temple had been dedicated six years earlier, and Utah had become a state only three years earlier." As for Idaho, it had been a state for just nine years.

When Benson died in 1994, funeral services were held in the church's Salt Lake Tabernacle at Temple Square in Salt Lake City, but unlike other presidents of the church, his body was transported back home to the small town of Whitney, where it lies at rest in that local cemetery.

Ezra Pound was born on October 30, 1885, in Hailey, Idaho, and made a name and reputation for himself that has become immortal. T.S. Eliot hailed Pound as having been "more responsible for the twentieth-century revolution

in poetry than is any other individual." His political career was something else entirely; he was branded by some as a traitor for broadcasting fascist propaganda to the United States during World War II.

In 1924, Pound moved to Italy to begin a self-imposed exile and did not return to the United States until 1945 and shortly thereafter was arrested for treason. Though he was acquitted a year later, he was declared mentally ill and committed to St. Elizabeth's Hospital in Washington, D.C. Despite his political stance and mental makeup at the time, he had accomplished much with his literary pen that caused fellow writers to honor him with the Bollingen-Library of Congress Award for his poem *Pisan Cantos* (1948). Writers, in fact, vied for his release, which Pound was granted in 1958. Like some other prominent figures with connections to Idaho, he never returned to the Gem State. Instead, Pound returned to Italy and died in Venice on November 1, 1972.

Joe Albertson, a philanthropist who founded the Albertson's grocery chain, was born in Oklahoma but arrived with his parents to the Gem State when he was three years old. They settled in Caldwell, the place where young Joe grew to maturity and began planning the rest of his life. After graduating from Caldwell High School in 1925, he attended the College of Idaho in his hometown. It is there where he began his grocery career, securing a job as a clerk at the local Safeway. He climbed the business ladder and soon was in management,

supervising multiple stores. His dreams grew larger than his position, however: he wanted to own his own store. His dream came true in 1939 when he opened his own retail outlet. That was just the beginning, though. Albertson's grew into a name-brand chain in many parts of the West, and Joe and his wife, Kathryn, continued to give back to Idaho communities and established the J.A. and Kathryn Albertson Foundation, a charitable organization that helps further education and other notable causes.

John Gutzon de la Mothe Borglum, better known as Gutzon Borglum, went down in the history books—and in the stone archives of Mother Earth—for creating the iconic presidential faces at Mount Rushmore National Monument in South Dakota. The magnificent sculptures have become a symbol of American pride and patriotism, and thousands of people across the country and from other nations visit the monument every year to see and take pictures of the landmark spectacle that is Mount Rushmore.

As for the sculptor, Borglum hailed from a Mormon polygamous family. His parents were Danish immigrants, but he was born in St. Charles in 1867. His father, Jens Møller Haugaard Børglum, a woodcutter, had two wives when he lived in Idaho: Gutzon's mother and her sister. He later became disenchanted with Mormonism and decided to move back to Omaha, taking only his first wife with him. Borglum's mother was left in Idaho.

Marjorie Reynolds was an American film and television actress, best known for her role in the 1942 movie *Holiday Inn*, wherein she appeared alongside Bing Crosby and sang "White Christmas," introducing the holiday classic to the world. Her tie to Idaho: she was born in the small town of Buhl in Twin Falls County.

Other films in which she appeared include major roles in *Ministry of Fear*, *Up in Mabel's Room* and *The Time of Their Lives* and a small role in *Gone with the Wind* and numerous other features. Before displaying her talent in the movies that made her famous, Reynolds appeared as a child actress in a number of silent films.

She died of congestive heart failure while walking her dog on February 1, 1997, in Manhattan Beach, California, but her memory and her many on-screen characters live on in the film and digital realm.

Sacajawea, from the tribe of Shoshone Indians, was born about 1790 in present-day Idaho and is known in history for her role in the Lewis and Clark Corps of Discovery Expedition, 1805–06. The expedition party, commissioned by President Thomas Jefferson and consisting of about thirty-four persons, traveled some two thousand miles from the Midwest to the Pacific Northwest to search the backcountry of the western United States in an effort to document the "face of the country."

The young woman known to history as the Shoshone's most famous had an interesting, if not turbulent, life that had spanned not much more than two decades when she died at the age of twenty-four. Sometime in her youth, Sacajawea was kidnapped by the Hisatsa Tribe and taken to their village near present-day Bismarck, North Dakota, according to information on an ancestry website that credits the book *Sacajawea* by Harold P. Howard.

Later, a French Canadian fur trapper, Charbonneau, bought the young maiden for his wife. Charbonneau later joined the expedition, bringing sixteen-year-old Sacajawea along with him—perhaps not the best adventure for a young pregnant woman. And yet she proved her mettle—and more. Sacajawea in many ways was a bright spot to the expedition, as she was familiar with the land and brought a feminine touch, perhaps even a little eye candy, if you will, to the otherwise testosterone-heavy party. She has been an inspiration for many, an emblem of women's worth and independence.

Vardis Fisher was born on March 31, 1895, in Annis, Idaho, in Jefferson County. Does the name sound familiar? Fisher was a "gifted novelist who," according to History. com, "dealt with both the myth and reality of the American West." Though he attended schools of higher education in Illinois and Utah, it was Idaho that he called home. He was "one of the most important forces for establishing a uniquely western voice in American literature," the website explains. "His greatest influences as a writer came through the many western novels he published, but he also taught English periodically throughout his career. Among the students he influenced was the great western writer Wallace Stegner."

Some of his more popular works include *Mountain Man* (1965), *Jeremiah Johnson* (1972) and *Tale of Valor* (1958), the latter a historical novel on the Lewis and Clark Corps of Discovery Expedition. He also wrote *Testament of Man*

(1943–60), a long and controversial series that explores the history of humankind from the primitive age to civilization. Not one who liked to be compared with other writers with Idaho connections, such as Ernest Hemingway and Ezra Pound, Fisher was a self-made writer who is revered by many to this day for his own unique works.

Part VIII

Historical Tidbits and Oddities

Chapter 29

Underwater Cars at Lake Coeur d'Alene

One of the more scenic and pretty places in the Gem State is Lake Coeur d'Alene in Idaho's panhandle. The lake, formed some twelve thousand to fifteen thousand years ago by the Missoula Floods and today with a surface area of nearly fifty square miles, is a popular attraction all year long but especially during summer when bald eagles feed on its kokanee. People will come here with their binoculars and cameras, as well as their fishing poles to try their own luck at catching salmon.

It is not only fish that call the cold lake their home; so do a number of old-style automobiles and even steamboats—things you can't rightly pull out of the water with a rod and reel. How these machines got to the bottom of the lake has to do with a mix of man's stupidity and impatience and Mother Nature.

In winters of the early 1900s, when, much like today, time was considered a precious commodity, people would

drive over the frozen lake to reach the other side instead of driving around it. Ice thickness and strength are variable on such a massive body, however, and some of the cars went to the bottom.

It is also reported that a few steamboats rest on the bottom of Lake Coeur d'Alene, having been retired to the flames and then sunk once they were no longer needed to

ferry people across the lake. In one way it's a shame that such things as cars and boats have made the lake their graveyard, but in another way it's an exciting opportunity for those experienced at diving. Thrill seekers visit the lake every year with their fins and swim masks to explore the bottom and see these relics that time and tale almost forgot.

Chapter 30

Stuff You Should Know Just for the Heck of It

A Girl's Favorite State?

Idaho's nickname, as we all know, is the Gem State. If the saying is true about diamonds being a woman's best friend, then the fairer sex just might consider Idaho their favorite member of the union. Why? Because one of the largest diamonds found in the United Sates was found near McCall, a scenic spot home to Payette Lake. The diamond was nearly twenty carats and is the envy of females across the land. In all, Idaho produces more than seventy types of precious and semiprecious stones, some of which cannot be found anywhere else.

Bates Motel

You don't have to visit Hollywood's Universal Studios to see the Bates Motel—that creepy movie set that Norman

Bates managed in Alfred Hitchcock's classic thriller *Psycho*. All you have to do is visit Coeur d'Alene, which has its very own Bates Motel.

"This Bates Motel is the real deal," reads a July 8, 2009 *Los Angeles Times* article about the facility, "a lodging at 2018 Sherman Ave. in Coeur d'Alene, Idaho, with 13 rooms and a manager's unit arrayed around a ragged parking lot. It sits along the gritty east end of Coeur d'Alene's main drag…The following warning is posted at the front desk: 'Party policy: No. Don't do it. Don't think about doin' it. And don't ask.'"

Built during World War II, the facility was used as officers' quarters of the Farragut Naval Training Station, which was named after David Farragut, the first admiral of the U.S. Navy and leading naval officer during the Civil War. Today, Farragut State Park sits on the southern tip of Lake Pend Oreille in the Coeur d'Alene Mountains. The officers' quarters became the motel in the 1950s.

It's a historic property but one that—perhaps because of its name—is rumored to be haunted by restless spirits, as explained in *Haunted Idaho*. Most of the alleged activity occurs in room numbers 1 and 3. According to the stories, lights turn on and off by themselves, objects have moved of their own volition and items placed in one spot are later found in another. Want to find out if the stories are true? Book a reservation.

BUILDING OF THE PERRINE BRIDGE

Been to Twin Falls or Jerome, Idaho? Then you likely remember the bridge they share, which spans the Snake River Canyon between the two counties. Built in the 1970s, the Perrine Bridge replaced the Twin Falls–Jerome Intercounty Bridge, which was a toll bridge built in the 1920s. Tolls were eliminated in the 1940s after the state of Idaho purchased the bridge. Thirty years later, in the 1970s, the bridge began to show its wear and needed replacing, and plans were made for a larger, more modern bridge, which also has become an iconic landmark of the counties' line. The current bridge is a four-lane truss arch that was started in 1973 and completed in 1976 at a cost of nearly $10 million. The original cantilever bridge, farther west, was demolished, while the new bridge was given a new name: I.B. Perrine, after the Twin Falls founder and one of the area's most ambitious irrigators at the time.

CASSIDY IN MONTPELIER

The date was August 13, 1896. The place was Montpelier. The character, an outlaw best known as Butch Cassidy. It was on that date and in that place that Cassidy robbed a bank, fleeing with more than $7,000. There's never a good reason to rob a bank—or anything else—but apparently Cassidy thought so. He was going to use the money to hire

a lawyer for his friend and outlaw partner, Matt Warner. The man was awaiting trial for murder in Ogden, Utah. Maybe Cassidy didn't hear the saying: the road to hell is paved with good intentions.

FACE IN THE ROCKS

One of the most popular attractions in the Magic Valley is Shoshone Falls (pronounced Show-Shown), dubbed the Little Niagara of the West because water here drops 212 feet, about 36 feet farther than New York's popular waterfall. Shoshone Falls, located in Twin Falls County, was created during the Bonneville Flood some fifteen thousand years ago and has been a landmark for Indians, explorers and adventurers ever since it was first encountered. Today managed by the Twin Falls Parks and Recreation Department, Shoshone Falls Park is visited by thousands of people every year. Those who travel through the area often seek out the falls as one of their must-see Idaho sites along their way to other destinations. It is a family-friendly park, with several viewing points to snap picturesque images of the mighty falls. Water, which is regulated by the Idaho Power Company, cascades over the rocks at 3,578 cubic feet per second in April and June, the months when the falls are fullest. Great mists rise in the air, sometimes beholden with a rainbow in their center.

And if you ask some people, or if you're one of the lucky ones to see it, there is a face in the falls that appears very much

like a bearded man, some saying it resembles the facial image of the typical Jesus painting. I have never seen it myself, but I have talked with some who have. Is this one of those places where, with the activity of rushing water, images come to light in the mind's eye, much like they do with moving clouds? One person might see a lazy cat or an angry giraffe, while another person might see a sailing ship or a charging rhinoceros. Perhaps the best way to find out is to visit the park yourself to see if you, too, can see a face in the falls.

INVENTOR OF THE BOOB TUBE

Millions of people across the world pay tribute to Philo T. Farnsworth—and a little homage to Idaho—every day and night whenever they turn on the boob tube, for it was Farnsworth who pioneered television technology, making strides that would forever change the way people spent their evenings. He developed the first television with receiver and camera, which he produced from 1938 to 1951 under the Farnsworth and Television Corporation. The Idaho connection: Farnsworth, born in Utah to Mormon parents, moved to Rigby, where he excelled in chemistry and physics at the local high school. Oh, and something else about the inventor: he was posthumously presented the Eagle Scout award in 2006 after it was made known that he had earned the award but never received it in his youth. His wife, Pem, accepted the award on his behalf—and died four months later.

MOUNTAIN STANDARD TIME

The majority of Idahoans would be living by Pacific Standard Time if not for Frank Gooding, an early state governor who, in the 1920s, sponsored a bill to put all of southern Idaho in the MST zone. Previously, the Interstate Commerce Commission had two-thirds of the state in PST zone. If you live—or pass through—Coeur d'Alene, for instance, you'll be in the Pacific Time Zone. Head farther south, however—not east—and you'll wind up in the Mountain Time Zone.

SUN VALLEY: HOME TO THE WORLD'S FIRST SKI LIFTS

Sometimes the best entrepreneurs are sports enthusiasts—and there are no more enthusiastic people in Idaho than snow bunnies and ski junkies. Every winter these colorful and daring people, donned in vinyl jackets and beanies, head to one of the Gem State's many ski resorts to ride the mountain slopes. One of the most popular destinations is Sun Valley and its array of family-friendly and challenging mountainsides. Bald Mountain, nicknamed Baldy by the locals, is a favorite place to ski or snowboard.

Skiing down a mountain slope is tons of fun. But dang it all, it's not fun climbing the mountain to ski down it. Thank goodness—nowadays—for ski lifts. But what did they do in

the old days? With world-class skiing, it's no wonder that the very first ski lifts were installed on Proctor Mountain at Sun Valley. At the time, 1936–37, the resort was owned by the Union Pacific Railroad. James Curran, a UPR engineer, developed the lifts in 1936. Patented as the "Aerial Ski Tramway," his basic design is still used today.

THE NAUTILUS COMES TO LIFE

You may never look at Idaho the same way again. Did you know that in 1953, a prototype of the country's first nuclear submarine, the *Nautilus*, was constructed and tested near Arco? The name might sound familiar in more way than one; the sub was named after the famous vessel in Jules Verne's classic adventure story, *Twenty Thousand Leagues Under the Sea*, as well as a submarine by the same name that served in World War II. As for this latter 1950s vessel, it was the first to complete a submerged voyage to the North Pole some five years after the prototype testing in Idaho.

WAR HORSE

Farms and fields across Idaho are decorated with horses of many varieties, but it is the Appaloosa that has special ties to the state. It was in the Kamiah Valley, among the ancestors of the Nez Perce Indians, that the partially to fully spotted animal was first bred and trained as a war horse. The horses have since become signature trademarks of the Indians and are depicted with Native Americans in many paintings of the Old West.

Bibliography

Abraham Lincoln Online. Second Inaugural Address. http://www.abrahamlincolnonline.org/lincoln/speeches/inaug2.htm.

Burnett, Jim. "Hagerman Fossil Beds National Monument Closed until Further Notice Due to Wildfire." National Parks Traveler, August 26, 2010. http://www.nationalparkstraveler.com/2010/08/hagerman-fossil-beds-national-monument-closed-until-further-notice-due-wildfire6474.

Burton, J., M. Farrell, F. Lord and R. Lord. "Confinement and Ethnicity: An Overview of World War II Japanese American Relocation Sites." http://www.cr.nps.gov/history/online_books/anthropology74/ce9.htm.

Dary, David. *The Oregon Trail: An American Saga.* New York: Oxford University Press, 2005.

"The Death of President Lincoln, 1865." http://www.eyewitnesstohistory.com/lincoln.htm.

Dolan, Maureen. "'Forgotten War' Recalled: Film Honors Amy Trice, Documents History of Kootenai Tribe." *Cour d'Alene (ID) Press*, November 16, 2012. http://www.cdapress.com/news/local_news/article_4d970deb-d3b2-5a2e-9d20-65d93deaa807.html?mode=jqm.

"Edgar Rice Burroughs." http://oprf.com/Burroughs/biography.html.

"Evel Knievel's Snake River Jump Monument." RoadsideAmerica.com. http://www.roadsideamerica.com/story/2961.

"Ezra Pound: 1885–1972." http://www.poetryfoundation.org/bio/ezra-pound.

"Ezra Taft Benson: Thirteenth President of the Church." The Church of Jesus Christ of Latter-day Saints. https://www.lds.org/manual/presidents-of-the-church-teacher-manual-religion-345/ezra-taft-benson-thirteenth-president-of-the-church?lang=eng.

"Fort Boise Military Cemetery." City of Boise. http://www.cityofboise.org/Departments/Parks/CaringForParks/Cemeteries/page3812.aspx.

Geranios, Nicholas K. "Kooskia Internment Camp Discovered in Mountains of Idaho." Associated Press, June 27, 2014. http://www.huffingtonpost.com/2013/07/27/kooskia-internment-camp_n_3663446.html.

Hillinger, Charles. "Old Penitentiary Gets a Reprieve: Idaho Institution Converted to Museum of Prison History." *Los Angeles Times*, January 9, 1987. http://articles.latimes.com/1987-01-09/news/vw-2771_1_penitentiary.

"Idaho's First Execution in 17 Years." http://boisestatepublicradio.org/post/idaho-s-first-execution-17-years.

Idaho's Forgotten War. http://www.idahosforgottenwar.com/.

"Idaho's Jack the Ripper." http://urbanlegendsonline.com/idahos-jack-the-ripper/.

Koch, Blair. "Water and Fun at Murtaugh's Caldron Linn." *Times-News* (Twin Falls, ID), May 6, 2009.

Legends of America: Idaho. http://www.legendsofamerica.com/id-facts.html.

Matthews, Mychel. "Hidden History: The Mummy of 'John Wilkes Booth.'" *Times-News* (Twin Falls, ID), October 11, 2012. http://magicvalley.com/news/local/hidden-history-the-mummy-of-john-wilkes-booth/article_4f6055d1-ca44-53cd-9cdc-63ed0f4dbef6.html.

National Park Service. "Hagerman Fossil Beds National Monument, Idaho: Hagerman Horse—Equus simplicidens." http://www.nps.gov/hafo/naturescience/hagerman-horse.htm.

———. "Minidoka: National Historic Site. History & Culture." http://www.nps.gov/miin/historyculture/index.htm.

"Philo T. Farnsworth: Inventor, 1906–1971." http://www.biography.com/people/philo-t-farnsworth-40273#synopsis.

"Sacajawea." http://www.rootsweb.ancestry.com/~nwa/sacajawea.html.

"Three Island Crossing Reenactment Coming to an End." KTVB, October 14, 2009. http://www.ktvb.com/story/news/local/2014/06/27/11490881/.

"The Water Babies of Massacre Rocks." Weird U.S. http://weirdus.com/states/utah/stories/water_babies/index.php.

Weeks, Andy. "The Death of Gobo Fango." *Wild West*, December 2011.

———. *Ghosts of Idaho's Magic Valley: Hauntings and Lore.* Charleston, SC: The History Press, 2012.

———. *Haunted Idaho: Ghosts and Strange Phenomena of the Gem State.* Mechanicsburg, PA: Stackpole Books, 2013.

———. "More to See Than Rocks at Castleford Monument." *Times-News* (Twin Falls, ID), April 1, 2009.

———. "Mormon Town: Impressions of Oakley from an Outsider." *Times-News* (Twin Falls, ID), November 28, 2009.

———. "On the Beaten Path: The Oregon Trail through the Magic Valley, Yesterday and Today." 2 parts. *Times-News* (Twin Falls, ID), August 12 and 19, 2010.

———. "A Sacred, Silent Land: Kimberly Man Claims 'the Ancient Ones' Once Lived on His Property." *Times-News* (Twin Falls, ID), November 11, 2010.

Weland, Mike. "Documentary Tells Story of 'Idaho's Forgotten War.'" *Bonner County (ID) Bee*, August 6, 2010. http://idahoptv.org/press/showStory. cfm?StoryID=47550.

Wikipedia. www.wikipedia.org.

Woodward, Tim. "'Idaho's Forgotten War' Celebrates Kootenai People and Amy Trice." *Landmark News*. http://www.landmarkeducationnews.com/events/ idahos-forgotten-war-celebrates-kootenai-people-and-amy-trice/.